The Best of
Business Card
Design 3

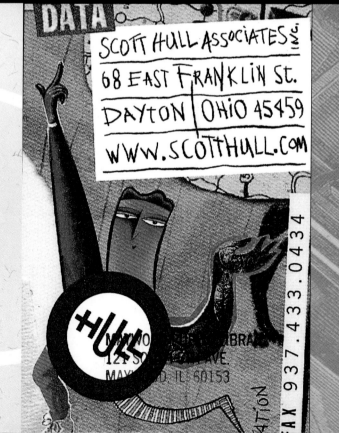

SCOTT HULL ASSOCIATES INC.
68 EAST FRANKLIN St.
DAYTON | OHIO 45459
WWW.SCOTTHULL.COM

HULL

FAX 937.433.0434

P 343.5116 F 206.343.7170 KEN WIDMEYER

First published in the United States of America by:
Rockport Publishers, Inc.
33 Commercial Street
Gloucester, Massachusetts 01930-5089
Telephone: (508) 282-9590
Facsimile: (508) 283-2742

Distributed to the book trade and art trade in the United States by:
North Light Books, an imprint of
F & W Publications
1507 Dana Avenue
Cincinnati, Ohio 45207
Telephone: (800) 289-0963

Other Distribution by:
Rockport Publishers, Inc.
Gloucester, Massachusetts 01930-5089

ISBN 1-56496-365-9

10 9 8 7 6 5 4 3 2 1

Designer: Debra S. Ball
Front Cover Images: (clockwise from top), pp. 36, 20, 26, 22, 21
Back Cover Images: (left to right), pp. 76, 39, 98

Printed in Hong Kong by Midas Printing Limited

The Best of Business Card Design 3

ROCKPORT PUBLISHERS
GLOUCESTER, MASSACHUSETTS
DISTRIBUTED BY NORTH LIGHT BOOKS,
CINCINNATI, OHIO

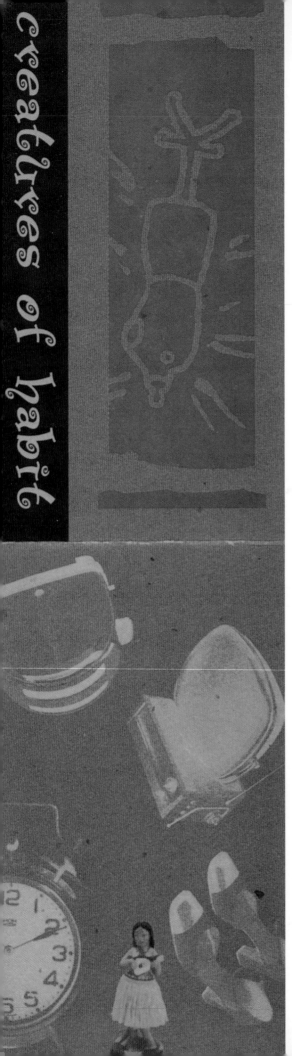

Introduction

D on't let the small size fool you—the business card is one of the most important pieces of corporate identity a business or person has. It is sometimes the only piece of information left behind after a contact is made; just a small, but insistent, reminder of a person after the physical presence is gone. Everybody has a business card: all sizes and types of businesses, even individuals create a card. It is the common denominator at all business meetings and will probably continue to be, despite changes in other sectors of the business world.

The computer age has changed the way people work and present themselves to others in the business community. With the advent of facsimile machines, it was no longer necessary to have colorful letterheads or fancy paper stock stationery since it all comes out black-and-white on the other side anyway. Now, with the advent of the World Wide Web, fancy paper and colors are translated into fancy graphics and 256-color monitors. Yet through this all, the business card has held its place. Even the "electronic Rolodexes" have not altered its position in the business world. No other piece of paper can take the place of that little business card; that small, physical reminder can make or break a business deal simply by reminding the client of the holder's services.

Designing a business card may appear to be simple, but designing a good business card is a real challenge. Think of the necessary elements: the person's name, job title, company, the

address, and other essentials. This list can get pretty long if phone, fax, e-mail, Website, and the lot are all included. You would think that this would leave room for little else. But look at the designs in this book: there is an abundance of graphics, colors, logos, and extra elements. None of them seem to be restricted or in any way held back by the text; all are successfully designed.

It all boils down to two things: will the card be kept and will the person be remembered. Many business cards get tucked into a Rolodex, a drawer, or a pocket almost as a reflex, so the first goal is achieved. A catchy, effectively designed business card will reassert itself repeatedly in the memory of the client, and even in the Rolodex. It is that second factor which proves success or failure.

The details do make a difference. How many colors? Which paper weight? Will it be printed two-sided? Size and shape also play a role, but a risky one. By opposing the norm, there is chance that your card will be stuck away from the competition because it does not fit the standard sleeves, boxes, or wherever the cards are kept. Or it might mean that your card retains the front-center position in its non-conformity. Chances, chances. This little card needs to make a big impact, and these decisions will make the difference. Choose wisely and you will be rewarded, I guarantee it.

Steven Pearson, designer

JACK CODY &
NATALYA HADEN
OWNERS

creatures

- COSTUME RENTAL
- ANTIQUES
- VINTAGE CLOTHING

of habit

406 BROADWAY

PADUCAH, KY 42001

502 442 2923

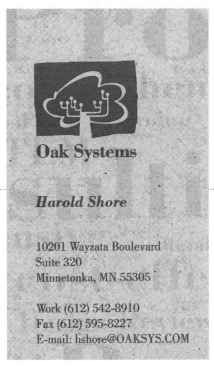

DESIGN FIRM Design Center
ART DIRECTOR John Reger
DESIGNER Sherwin Schwartzrock
CLIENT Oak Systems
TOOLS Macintosh
PAPER/PRINTING Procraft Printing

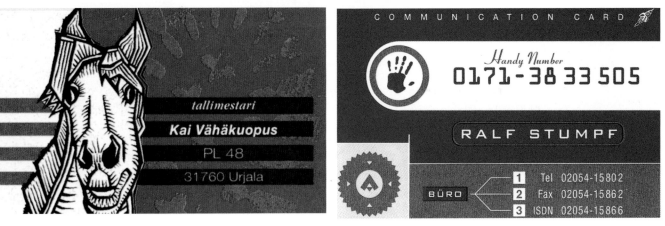

DESIGN FIRM M-DSIGN
ALL DESIGN Mika Ruusunen
CLIENT Kai Vähäkuopus
TOOLS Macintosh
PAPER/PRINTING Offset

DESIGN FIRM Design Ahead
DESIGNER Ralf Stumpf
CLIENT Ralf Stumpf
TOOLS Macromedia FreeHand, Macintosh

DESIGN FIRM LSL Industries
DESIGNER Elisabeth Spitalny
CLIENT JP Davis & Co.
TOOLS QuarkXPress
PAPER/PRINTING French Newsprint White

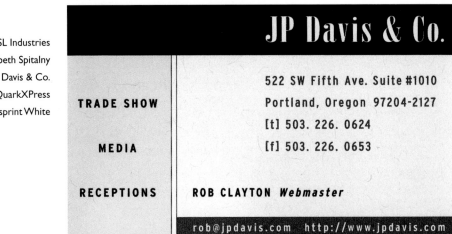

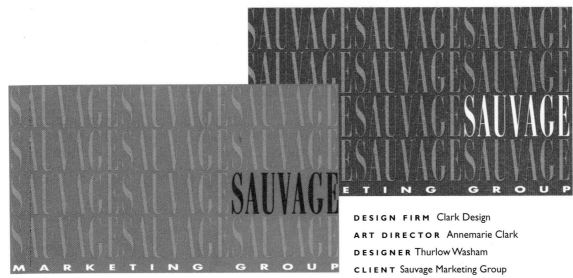

DESIGN FIRM Clark Design
ART DIRECTOR Annemarie Clark
DESIGNER Thurlow Washam
CLIENT Sauvage Marketing Group
TOOLS QuarkXPress
PAPER/PRINTING Strathmore Cover

DESIGN FIRM 9 Volt Visuals
ART DIRECTOR/DESIGN Bobby Jones
CLIENT 23 Skateboards
TOOLS Adobe Illustrator
PAPER/PRINTING Twin Concepts

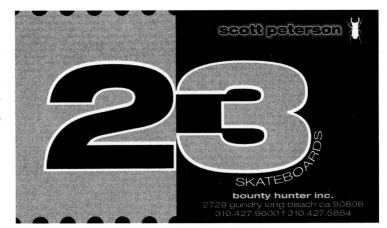

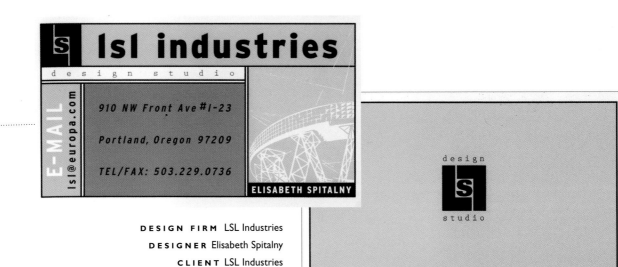

DESIGN FIRM LSL Industries
DESIGNER Elisabeth Spitalny
CLIENT LSL Industries
TOOLS QuarkXPress, Adobe Photoshop
PAPER/PRINTING Encore 130 lb. gloss

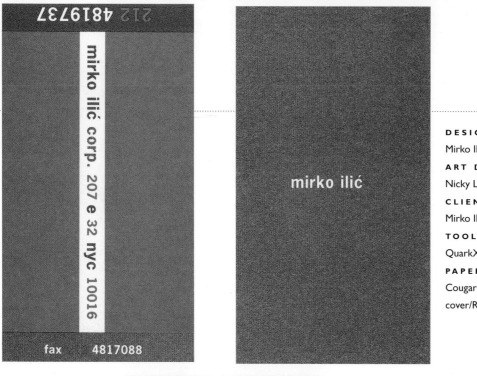

DESIGN FIRM
Mirko Ilić Corp.
ART DIRECTOR/DESIGNER
Nicky Lindeman
CLIENT
Mirko Ilić Corp.
TOOLS
QuarkXPress
PAPER/PRINTING
Cougar Smooth white 80 lb.
cover/Rob-Win Press

DESIGN FIRM
Di Luzio Diseño
ART DIRECTOR/DESIGNER
Hector Di Luzio
PAPER/PRINTING
Screen-printed

DESIGN FIRM Design Infinitum
ALL DESIGN James A. Smith
CLIENT French Quarter
TOOLS QuarkXPress, Adobe Illustrator

DESIGN FIRM Widmeyer Design
ART DIRECTORS Dale Hart, Tony Secolo
DESIGNER Tony Secolo
ILLUSTRATOR Misha Melikov
CLIENT The Production Network
TOOLS Power Macintosh,
Macromedia FreeHand
PAPER/PRINTING UV Ultra/Offset

DESIGN FIRM Amplifier Creative
DESIGNER/ILLUSTRATOR Jeff Fuson
CLIENT Amplifier Creative
TOOLS Adobe Photoshop
PAPER/PRINTING Four-color process

DESIGN FIRM Multimedia Asia
ART DIRECTOR G. Lee
ILLUSTRATOR J. E. Jesus
CLIENT Multimedia Asia
TOOLS PageMaker
PAPER/PRINTING Milkweed
Genesis 80 lb./Four-color process

DESIGN FIRM MA&A—Mário Aurélio & Associados
ART DIRECTOR Mário Aurélio
DESIGNERS Mário Aurélio, Rosa Maia
CLIENT Decopaço

DESIGN FIRM Susan Guerra Design
ART DIRECTOR/DESIGNER Susan Guerra
CLIENT Wave Mechanics
TOOLS Adobe Illustrator
PAPER/PRINTING Classic Crest/Two color

DESIGN FIRM Sayles Graphic Design
ART DIRECTOR John Sayles
DESIGNERS John Sayles, Jennifer Elliott
CLIENT Consolidated Correctional Food Service
PAPER/PRINTING Graphika parchment gray riblaid/Offset


DESIGN FIRM Fire House, Inc.
ART DIRECTOR/DESIGNER Gregory R. Farmer
CLIENT Creatures of Habit
TOOLS QuarkXPress, Adobe Photoshop, Macintosh
PAPER/PRINTING Moore Laugen Printing Co.




DESIGN FIRM
Hieroglyphics Art & Design
DESIGNER/ILLUSTRATOR
Christine Osborn Tirotta
PHOTOGRAPHER
John Tirotta
CLIENT
Tirotta Photo Productions
PAPER/PRINTING
Starwhite Vicksburg UV Ultra II


DESIGN FIRM Jeff Fisher Logomotives
ALL DESIGN Jeff Fisher
CLIENT Barrett Rudich, Photographer
TOOLS Macromedia FreeHand
PAPER/PRINTING Fine Arts Graphics

THE BEST OF BUSINESS CARD DESIGN 3 11

DESIGN FIRM Fire House, Inc.
ART DIRECTOR/DESIGNER Gregory R. Farmer
CLIENT Creatures of Habit
TOOLS QuarkXPress, Adobe Photoshop, Macintosh
PAPER/PRINTING Moore Laugen Printing Co.

DESIGN FIRM
Hieroglyphics Art & Design
DESIGNER/ILLUSTRATOR
Christine Osborn Tirotta
PHOTOGRAPHER
John Tirotta
CLIENT
Tirotta Photo Productions
PAPER/PRINTING
Starwhite Vicksburg UV Ultra II

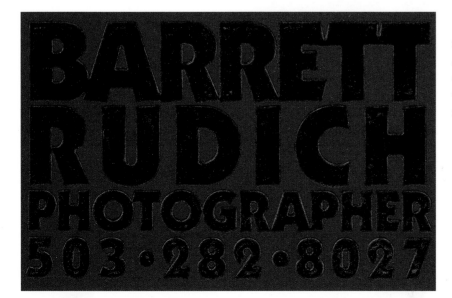

DESIGN FIRM Jeff Fisher Logomotives
ALL DESIGN Jeff Fisher
CLIENT Barrett Rudich, Photographer
TOOLS Macromedia FreeHand
PAPER/PRINTING Fine Arts Graphics

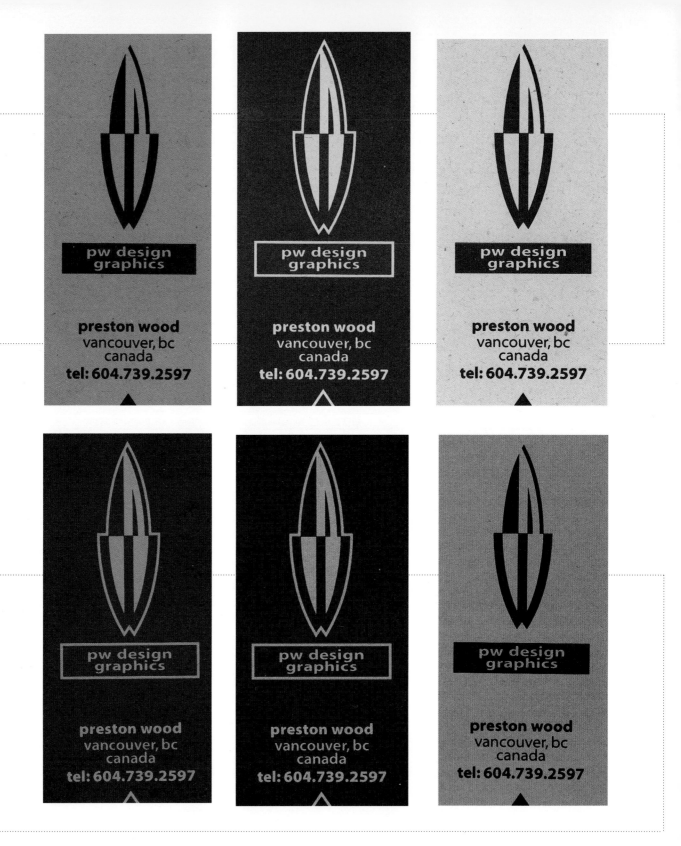

DESIGN FIRM pw design graphics

ART DIRECTOR/DESIGNER Preston Wood

CLIENT pw design graphics

TOOLS Adobe Illustrator

PAPER/PRINTING Domtar Naturals Brick, Neenah Classic Columns Green

4557 46TH AVENUE N.E.
SEATTLE, WASHINGTON 98105

VOICE: 206.527.8286
FAX: 206.524.6641

CARY PILLO LASSEN
ILLUSTRATOR

4557 46TH AVENUE N.E.
SEATTLE, WASHINGTON 98105

VOICE: 206.527.8286
FAX: 206.524.6641

CARY PILLO LASSEN
ILLUSTRATOR

4557 46TH AVENUE N.E.
SEATTLE, WASHINGTON 98105

VOICE: 206.527.8286
FAX: 206.524.6641

CARY PILLO LASSEN
ILLUSTRATOR

4557 46TH AVENUE N.E.
SEATTLE, WASHINGTON 98105

VOICE: 206.527.8286
FAX: 206.524.6641

CARY PILLO LASSEN
ILLUSTRATOR

DESIGN FIRM
Belyea Design Alliance
ART DIRECTOR
Patricia Belyea
DESIGNER
Tim Ruszel
ILLUSTRATOR
Cary Pillo Lassen
CLIENT
Cary Pillo Lassen

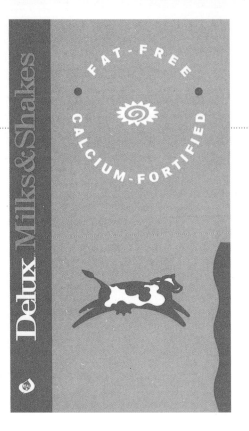

FAT-FREE
CALCIUM-FORTIFIED

Delux Milks&Shakes

F. KENNITH NIXON

President

MENDENHALL LABORATORIES, LLC

1042 MINERAL WELLS AVE.

PARIS, TN 38242

TEL 901-642-9321

1-800-642-9321

FAX 901 644 2398

DESIGN FIRM
Greteman Group
ART DIRECTORS/DESIGNERS
Sonia Greteman, James Strange
CLIENT
Delux
TOOLS
Macromedia FreeHand
PAPER/PRINTING
Cougar white/Two-color offset

DESIGN FIRM On The Edge
ART DIRECTOR/ILLUSTRATOR Jeff Gasper
DESIGNER Gina Mims
CLIENT Five Seven Five
TOOLS Adobe Illustrator, QuarkXPress
PAPER/PRINTING Karma Natural

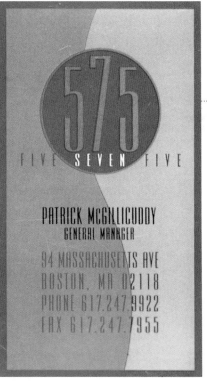

575
FIVE SEVEN FIVE

PATRICK McGILLICUDDY
GENERAL MANAGER

94 MASSACHUSETTS AVE
BOSTON, MA 02118
PHONE 617.247.9922
FAX 617.247.7955

HAIKU/Hi-ku/n,:
An unrhymed poem or verse of three lines containing usually (but not necessarily) five, seven, and five syllables respectively.

Haiku was born in 17th century Japan. It was adopted by New York and San Francisco beat poets in the 50's with the publication of Kerouac's "Dharma Bums".

One writes a haiku to recreate an intimate moment and communicate the feelings it inspired to another.

DESIGN FIRM Bluestone Design
ART DIRECTOR Ian Gunningham
ILLUSTRATOR Symon Sweet
TOOLS Macintosh
PAPER/PRINTING Silkscreen on PVC, opaque varnish

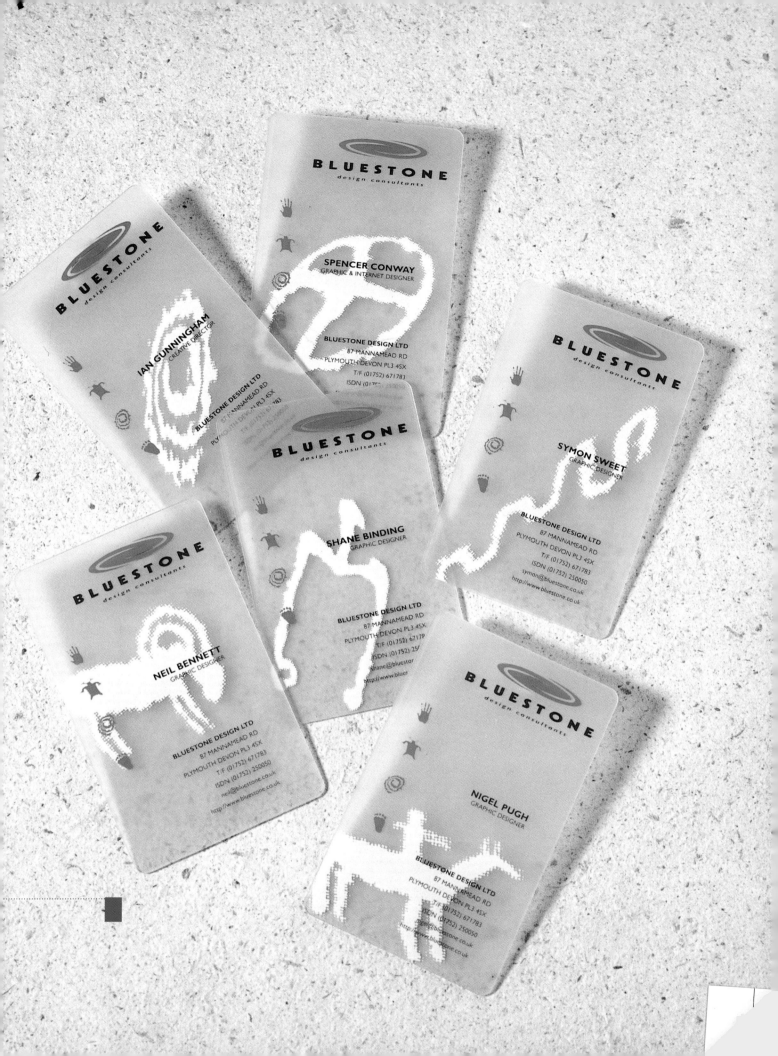

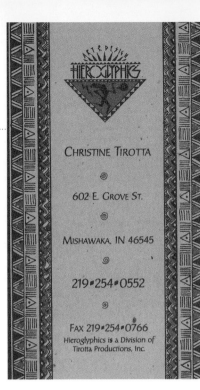

DESIGN FIRM
Hieroglyphics Art & Design
DESIGNER/ILLUSTRATOR
Christine Osborn Tirotta
CLIENT
Hieroglyphics Art & Design
PAPER/PRINTING
Fox River Confetti

DESIGN FIRM Elena Design
ALL DESIGN Elena Baca
CLIENT InterCity Services
TOOLS Adobe Illustrator,
QuarkXPress

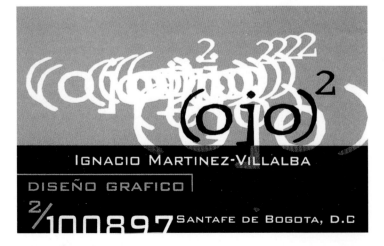

DESIGN FIRM (ojo)2
ALL DESIGN Ignacio Martinez-Villalba
CLIENT (ojo)2
TOOLS Macintosh
PAPER/PRINTING Opaline/Offset

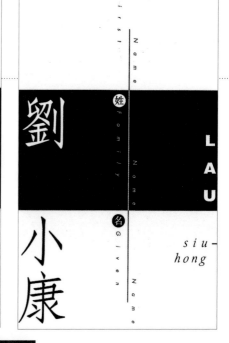

DESIGN FIRM
Kan & Lau Design Consultants
ART DIRECTOR/DESIGNER
Freeman Lau Siu Hong
CLIENT
Freeman Lau Siu Hong
PAPER/PRINTING
Conqueror Diamond White
250 gsm/Offset

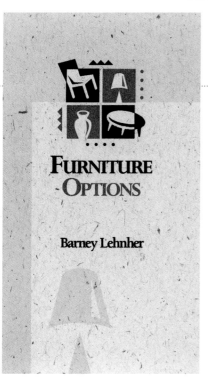

1336 East Douglas

Wichita, KS 67214

Tel 316-263-5750

Fax 316-269-3574

1-800-466-5750

DESIGN FIRM
Greteman Group
ART DIRECTORS/DESIGNERS
Sonia Greteman, James Strange
ILLUSTRATORS
James Strange, Sonia Greteman
CLIENT
Furniture Options
PAPER/PRINTING
Speckletone/Offset

DESIGN FIRM Stephen Peringer Illustration
DESIGNER/ILLUSTRATOR Stephen Peringer
CLIENT Paul Mader/DreamWorks
TOOLS Adobe Photoshop, pen, ink
PAPER/PRINTING LaValle Printing

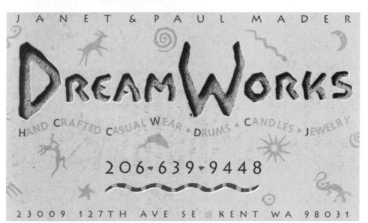

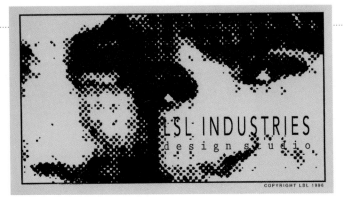

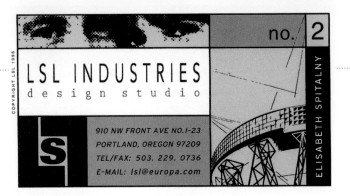

DESIGN FIRM LSL Industries
DESIGNER Franz M. Lee
CLIENT LSL Industries
TOOLS QuarkXPress, Adobe Photoshop
PAPER/PRINTING Encore 130 lb. gloss

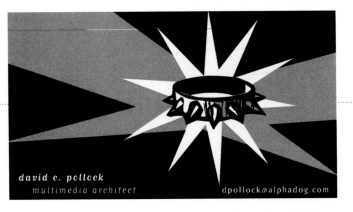

DESIGN FIRM Tanagram
ART DIRECTOR Lance Rutter
DESIGNER David Kaplan
CLIENT Alpha Dog
TOOLS Macromedia FreeHand,
Adobe Streamline
PAPER/PRINTING Strathmore Elements

DESIGN FIRM Mirko Ilić Corp.
ART DIRECTOR/DESIGNER Nicky Lindeman
CLIENT La Paella Restorante
TOOLS Adobe Illustrator
PAPER/PRINTING Cougar 80 lb. white smooth
cover/Rob-Win Press

DESIGN FIRM Sayles Graphic Design
ALL DESIGN John Sayles
CLIENT Timbuktuu Coffee Bar
PAPER/PRINTING Cross Pointe Genesis copper/Offset

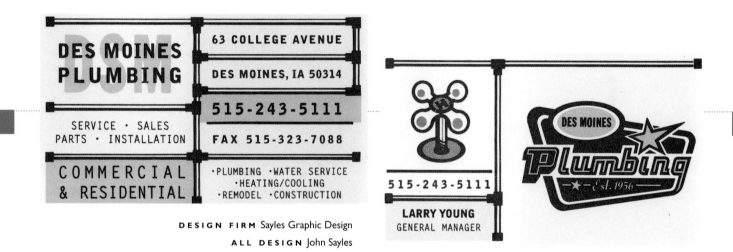

DESIGN FIRM Sayles Graphic Design
ALL DESIGN John Sayles
CLIENT Des Moines Plumbing
PAPER/PRINTING Neenah Classic Crest gray/Offset

DESIGN FIRM Duck Soup Graphics
ART DIRECTOR/DESIGNER William Doucette
CLIENT Lemmerick Marketing
TOOLS Macromedia FreeHand, QuarkXPress
PAPER/PRINTING Classic Columns/
Two match colors

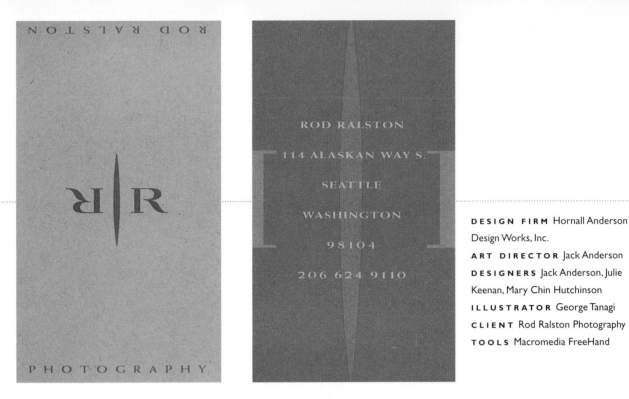

DESIGN FIRM Hornall Anderson Design Works, Inc.
ART DIRECTOR Jack Anderson
DESIGNERS Jack Anderson, Julie Keenan, Mary Chin Hutchinson
ILLUSTRATOR George Tanagi
CLIENT Rod Ralston Photography
TOOLS Macromedia FreeHand

DESIGN FIRM Gini Chin Graphics
ART DIRECTOR/DESIGNER Gini Chin
CLIENT 24.7 Marketing Bloc, Inc.
TOOLS Adobe Photoshop, QuarkXPress
PAPER/PRINTING Classic Crest

DESIGN FIRM Greteman Group
ART DIRECTORS/DESIGNERS Sonia Greteman, James Strange
CLIENT Grant Telegraph Centre
TOOLS Macromedia FreeHand
PAPER/PRINTING Genesis, Sticker/Three-color offset

DESIGN FIRM
Insight Design Communications
ART DIRECTORS/DESIGNERS
Sherrie Holdeman, Tracy Holdeman
CLIENT
Insight Design Communications
TOOLS
Power Macintosh 7500,
Macromedia FreeHand, Adobe Photoshop
PAPER/PRINTING
Dull Enamel Coat 65 lb. cover

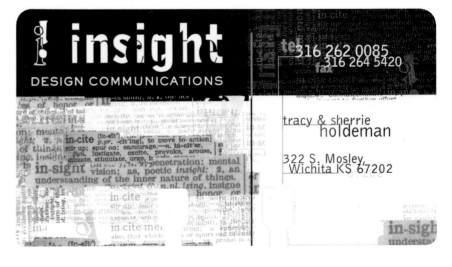

christian tours

telephone 800 505 tour facsimile 601 685 9066

post office box 447 blue mountain, ms 38610

barry goolsby
cruise consultant

DESIGN FIRM David Carter Design
ART DIRECTOR Lori B. Wilson
DESIGNER/ILLUSTRATOR Tracy Huck
CLIENT Christian Tours

DESIGN FIRM Melissa Passehl Design
ART DIRECTOR Melissa Passehl
DESIGNERS Melissa Passehl,
Charlotte Lambrechts
CLIENT Leadership Connection

Opening the way to change

LEADERSHIP
CONNECTION

Barbara Moore
Individuals•Teams•Organizations

1225 Brace Avenue
San Jose•CA•95125
Email•Lead@Leaders4U•com
Phone•408•286•7399
Fax•408•286•4715

335
High 415
Street 321
Palo Alto 2246
CA 94301

DESIGN FIRM Sandy Gin Design
DESIGNER/ILLUSTRATOR Sandy Gin
CLIENT Sandy Gin Design
TOOLS Macromedia FreeHand
PAPER/PRINTING Simpson Evergreen
80 lb. cover/One-color offset

Amphora

distinctive
gifts for
distinguished
people.

Post Office Box 781234
Wichita, KS 67278-1234
316.634.6887

DESIGN FIRM Greteman Group
ART DIRECTOR/ILLUSTRATOR Sonia Greteman
DESIGNERS Sonia Greteman, Craig Tomison
CLIENT Amphora
TOOLS Macromedia FreeHand
PAPER/PRINTING Genesis Script/Two-color offset

DESIGN FIRM
Siebert Design Associates
ART DIRECTOR Lori Siebert
DESIGNERS Lori Siebert,
Lisa Ballard
CLIENT Scott Hull Associates
PAPER/PRINTING Starwhite
Vicksburg/Arnold Printing

DESIGN FIRM Insight Design Communications
ART DIRECTORS/DESIGNERS
Sherrie Holdeman, Tracy Holdeman
CLIENT Kendall McMinimy Photography
TOOLS Power Macintosh 7500,
Macromedia FreeHand
PAPER/PRINTING French Speckletone Straw

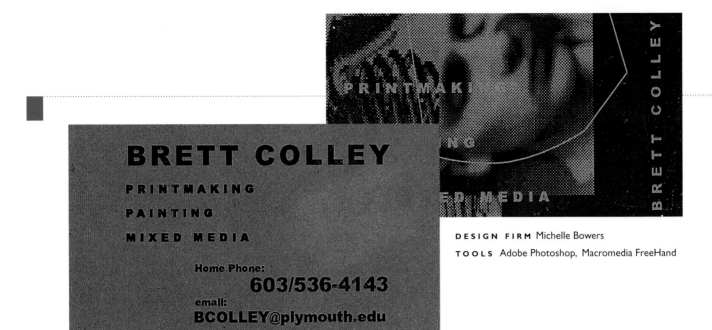

BRETT COLLEY

PRINTMAKING

PAINTING

MIXED MEDIA

Home Phone:
603/536-4143

email:
BCOLLEY@plymouth.edu

DESIGN FIRM Michelle Bowers

TOOLS Adobe Photoshop, Macromedia FreeHand

DESIGN FIRM
Icehouse Design
ART DIRECTOR
Pattie Belle Hastings
DESIGNER Bjorn Akselsen
CLIENT Graebel Fine Art
TOOLS Power Macintosh 8100

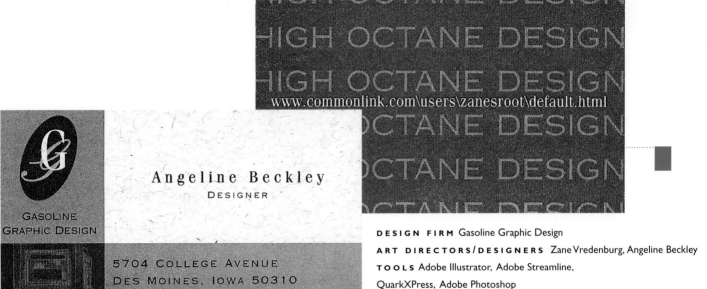

Angeline Beckley
DESIGNER

GASOLINE
GRAPHIC DESIGN

5704 COLLEGE AVENUE
DES MOINES, IOWA 50310
PH./FAX (515) 255-7095
GASGRAPHICS@COMMONLINK.COM

DESIGN FIRM Gasoline Graphic Design
ART DIRECTORS/DESIGNERS Zane Vredenburg, Angeline Beckley
TOOLS Adobe Illustrator, Adobe Streamline,
QuarkXPress, Adobe Photoshop
PAPER/PRINTING Neenah/Alpaca Christian Printers

WaterWorks

The Tavern

Summer House

The Oyster Bar

La Bodega

Eating Up The Coast, Inc.

Phil Cocco
Director of Operations

333 Victory Road, Marina Bay, Quincy, MA 02171
617-786-9600 • Fax 617-786-0700

DESIGN FIRM Flaherty Art & Design
ALL DESIGN Marie Flaherty
CLIENT Eating Up The Coast
TOOLS Adobe Illustrator

DESIGN FIRM Sagmeister, Inc.
ART DIRECTOR Stefan Sagmeister
DESIGNERS Veronica Oh, Stefan Sagmeister
PHOTOGRAPHER Michael Grimm
CLIENT Toto
PAPER/PRINTING Strathmore Writing 25% cotton

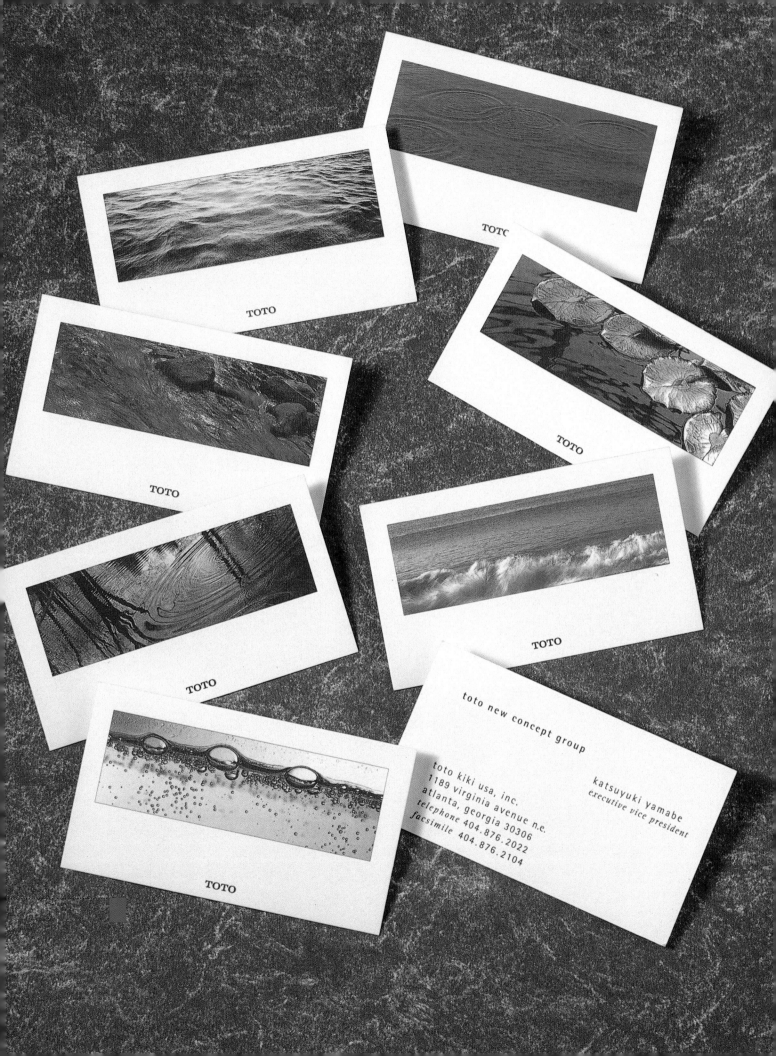

Ⓕ343.5116 Ⓣ206.343.7170 **DALE HART**

Ⓕ343.5116 Ⓣ206.343.7170 **KEN WIDMEYER**

Ⓕ343.5116 Ⓣ206.343.7170 **KEN WIDMEYER**

Ⓕ343.5116 Ⓣ206.343.7170 **ANTHONY SECOLO**

911 WESTERN #305 SEATTLE WA 98104 WIDMEYERDESIGN

DESIGN FIRM Widmeyer Design

ALL DESIGN Ken Widmeyer, Dale Hart, Tony Secolo

CLIENT Widmeyer Design

TOOLS Power Macintosh, Adobe Photoshop, Macromedia FreeHand

PAPER/PRINTING Stonehenge 100% cotton/Offset

L E N O X
R O O M

1278 THIRD AVENUE NEW YORK CITY 10021

TEL 212.772.0404 FAX 212.772.3229

L E N O X
R O O M

1278 THIRD AVENUE NEW YORK CITY 10021

TEL 212.772.0404 FAX 212.772.3229

TIP WELL AND PROSPER

L E N O X
R O O M

1278 THIRD AVENUE NEW YORK CITY 10021

TEL 212.772.0404 FAX 212.772.3229

L E N O X
R O O M

CHARLIE PALMER

1278 THIRD AVENUE NEW YORK CITY 10021

TEL 212.772.0404 FAX 212.772.3229

WWW.LENOXROOM.COM

DESIGN FIRM Aerial
ART DIRECTOR/DESIGNER Tracy Moon
PHOTOGRAPHER R. J. Muna
CLIENT Lenox Room Restaurant
TOOLS Adobe Photoshop, QuarkXPress

DESIGN FIRM Flaherty Art & Design
ALL DESIGN Marie Flaherty
CLIENT Grafton Street
TOOLS Adobe Illustrator

DESIGN FIRM Sagmeister, Inc.
ALL DESIGN Stefan Sagmeister
CLIENT Frank's Disaster Art
PAPER/PRINTING Strathmore Writing 25% cotton

DESIGN FIRM Sandy Gin Design
DESIGNER/ILLUSTRATOR Sandy Gin
CLIENT Sandy Gin Design
TOOLS Macromedia FreeHand
PAPER/PRINTING Simpson Starwhite Vicksburg
110 lb. cover/Two-color offset

DESIGN FIRM Insight Design Communications
ART DIRECTORS/DESIGNERS Sherrie Holdeman, Tracy Holdeman
CLIENT Clotia
TOOLS Power Macintosh 7500, Macromedia FreeHand, Adobe Photoshop
PAPER/PRINTING French Speckletone Oatmeal 80 lb. cover

DESIGN FIRM Stowe Design
ART DIRECTOR/DESIGNER Jodie Stowe
CLIENT Whizdom
PAPER/PRINTING Aztec Printing

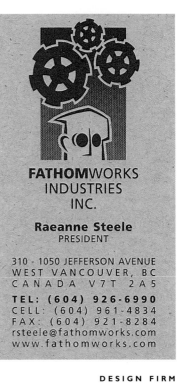

DESIGN FIRM
pw design graphics
ART DIRECTOR/DESIGNER
Preston Wood
CLIENT
Fathomworks Industries, Inc.
TOOLS
Adobe Illustrator
PAPER/PRINTING
Domtar Naturals Wicker Brick

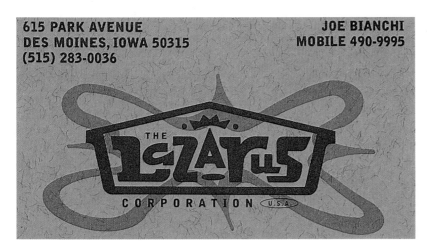

DESIGN FIRM Sayles Graphic Design
ALL DESIGN John Sayles
CLIENT Lazarus Corporation
PAPER/PRINTING Curtis Tuscan Terra,
Pacific blue/Offset

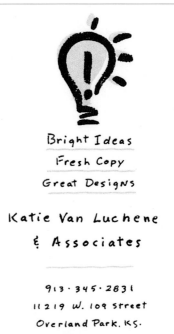

DESIGN FIRM Katie Van Luchene & Associates
ART DIRECTOR Katie Van Luchene
DESIGNERS Katie Van Luchene, Jan Tracy
ILLUSTRATOR Jan Tracy
CLIENT Katie Van Luchene
TOOLS Macromedia FreeHand, QuarkXPress
PAPER/PRINTING Zellerbach 90 lb. Riblaid/
Black and spot color

GRIEF COUNSELING +

MASSAGE THERAPY

TEL 206.545.4266

ROOM NUMBER 340
GOOD SHEPHERD CTR.

4649 SUNNYSIDE AVE. N.
SEATTLE, WA 98103

LANIE RILEY
M.S.W. + L.M.P.

LANIE RILEY
M.S.W. + L.M.P.

DESIGN FIRM Rick Eiber Design (RED)
ART DIRECTOR/DESIGNER Rick Eiber
CLIENT Lanie Riley
TOOLS Debossing Die
PAPER/PRINTING Two colors over one, watercolor crayon

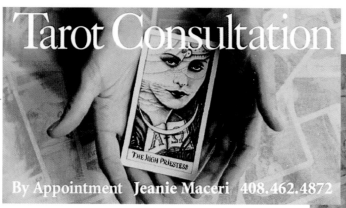

DESIGN FIRM Charney Design
ALL DESIGN Carol Inez Charney
CLIENT Jeanie Maceri
TOOLS QuarkXPress, Adobe Photoshop
PAPER/PRINTING Vintage/Offset

DESIGN FIRM Jill Morrison Design
ALL DESIGN Jill Morrison
CLIENT A Show of Hands
TOOLS Adobe Photoshop, Macromedia
FreeHand, QuarkXPress
PAPER/PRINTING Two color

A
SHOW
OF
HANDS

FULL SERVICE SALON

AMANI
owner/nail artist

408.371.8877

2160 S. Bascom Ave. Campbell, California
95008

DESIGN FIRM Prestige Design
ALL DESIGN Sarah Harris
CLIENT Creative Surfaces
TOOLS Adobe Illustrator, Adobe Photoshop, QuarkXPress
PAPER/PRINTING Speckletone Oatmeal/One PMS

APPLICATORS OF CONCRETE STAIN
SPECIALIZING IN UNIQUE DESIGNS

SARAH HARRIS
ARTIST

602 JOHNS' DRIVE
EULESS, TX 76039
METRO 817.540.1560
FAX 817.540.1680
VM/PAGER 817.858.1510

CREATIVE SURFACES

SIERRA SUITES℠
Stay Awhile℠

Sierra Suites Hotel
2010 Powers Ferry Road
Atlanta, Georgia 30339
Tel 770-933-8010
Fax 770-933-8181
For Reservations
Tel 800-474-3772

Maura Dube
Assistant Manager

DESIGN FIRM Greteman Group
ART DIRECTOR Sonia Greteman
DESIGNERS Sonia Greteman, James Strange
CLIENT Sierra Suites
TOOLS Macromedia FreeHand
PAPER/PRINTING Passport/Two-color offset

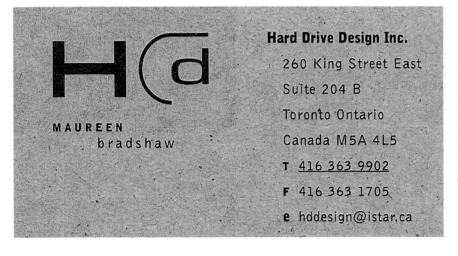

Hard Drive Design Inc.

260 King Street East

Suite 204 B

Toronto Ontario

Canada M5A 4L5

T 416 363 9902

F 416 363 1705

e hddesign@istar.ca

MAUREEN
bradshaw

DESIGN FIRM Hard Drive Design
ART DIRECTOR Maureen Bradshaw
DESIGNERS Eymard Angulo, Maureen Bradshaw
CLIENT Hard Drive Design
TOOLS QuarkXPress
PAPER/PRINTING Domtar Naturals Jute 80 lb. cover

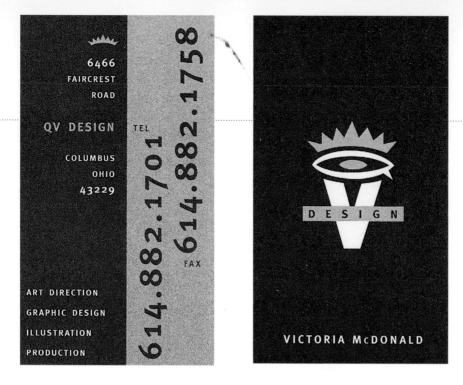

DESIGN FIRM
Angry Porcupine Design
DESIGNER/ILLUSTRATOR
Cheryl Roder-Quill
CLIENT
QV Design
TOOLS
Macintosh, QuarkXPress
PAPER/PRINTING
Strathmore Script/Two color

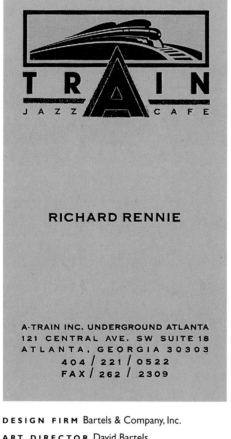

DESIGN FIRM Bartels & Company, Inc.
ART DIRECTOR David Bartels
DESIGNER/ILLUSTRATOR Brian Barclay
CLIENT A-Train Jazz Cafe
PAPER/PRINTING DeVere Printing

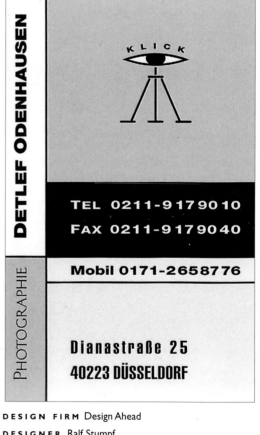

DESIGN FIRM Design Ahead
DESIGNER Ralf Stumpf
CLIENT Detlef Odenhausen
TOOLS Macromedia FreeHand, Macintosh

YOUR NEXT APPOINTMENT

This time is reserved exclusively for you. 24 hours notice is appreciated if you are unable to keep your appointment.

DESIGN FIRM Greteman Group
ART DIRECTOR/DESIGNER Sonia Greteman
CLIENT Eric Fisher Salon
TOOLS Macromedia FreeHand
PAPER/PRINTING Genesis/Two-color offset

DESIGN FIRM Design Ahead
DESIGNER Ralf Stumpf
CLIENT Fiction Factory
TOOLS Macromedia FreeHand, Macintosh

GARY L. MOREAU
PRESIDENT,
CHIEF EXECUTIVE OFFICER

THE LIONEL CORPORATION

50625 RICHARD W. BOULEVARD
CHESTERFIELD, MICHIGAN
48051-2493

TELEPHONE 810.949.4100
FACSIMILE 810.949.8721

DESIGN FIRM Michael Stanard Design, Inc.
ART DIRECTOR Michael Stanard
DESIGNERS Marc C. Fuhrman, Kristy Vandekerckhove
CLIENT Lionel Trains
PAPER/PRINTING Strathmore Bright White/Engraved, offset

Barbara Pyle
Board Member

Captain Planet Foundation
One CNN Center
Atlanta GA 30303
Phone 404 827 1918
Fax 404 827 4292
Internet: barbara.pyle@turner.com

Printed with vegetable based inks on 100% recycled paper

DESIGN FIRM Icehouse Design
ART DIRECTOR Pattie Belle Hastings
DESIGNER Bjorn Akselsen
ILLUSTRATOR Turner Broadcasting
System inhouse
CLIENT TBS
TOOLS Power Macintosh 8100
PAPER/PRINTING Benefit Natural Flax

CarolLasky

30 THE FENWAY BOSTON MA 02215

PHONE 617 353 0500 E-MAIL carol@cahoots.com FAX 617 424 8309

DESIGN FIRM Cahoots
ART DIRECTOR Carol Lasky
DESIGNER Erin Donnellan
ILLUSTRATORS Bill Mayers, Mark Allen
CLIENT Cahoots
TOOLS Adobe Illustrator, QuarkXPress
PAPER/PRINTING Strathmore Elements/The Ink Spot

Where Design and Marketing Fly

DESIGN FIRM Fordesign
ALL DESIGN Frank Ford
TOOLS Adobe Illustrator, Macromedia
Fontographer, Macromedia FreeHand,
Adobe Photoshop
PAPER/PRINTING
Various papers/Aluminum printing plate

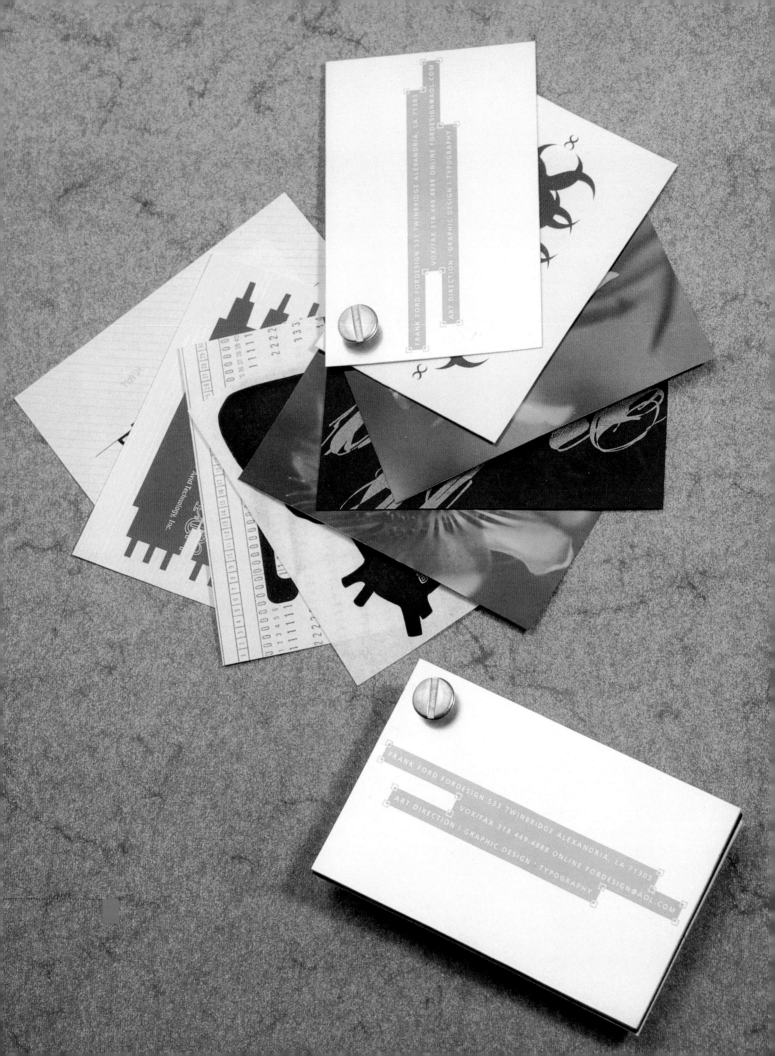

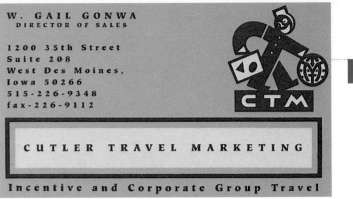

DESIGN FIRM Sayles Graphic Design
ALL DESIGN John Sayles
CLIENT Cutler Travel Marketing
PAPER/PRINTING Curtis Brightwater riblaid slate/Offset

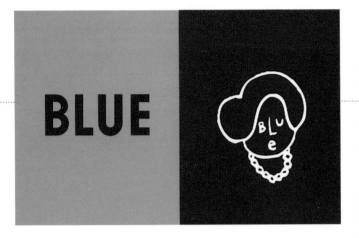

DESIGN FIRM Sagmeister, Inc.
ART DIRECTOR Stefan Sagmeister
DESIGNERS Stefan Sagmeister, Eric Zim
ILLUSTRATOR Stefan Sagmeister
CLIENT Blue Fashion Retail
PAPER/PRINTING Strathmore Writing 25% cotton

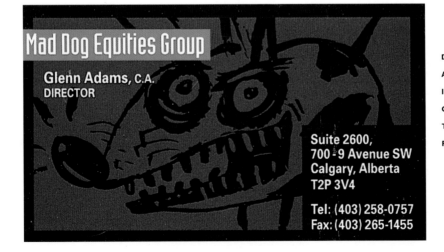

DESIGN FIRM Black Letter Design, Inc.
ART DIRECTOR/DESIGNER Ken Bessie
ILLUSTRATOR Rick Sealock
CLIENT Mad Dog Equities Group
TOOLS Adobe Illustrator, QuarkXPress
PAPER/PRINTING Expression Iceberg/Offset

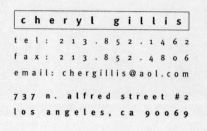

cheryl gillis
tel : 2 1 3 . 8 5 2 . 1 4 6 2
fax : 2 1 3 . 8 5 2 . 4 8 0 6
email : c h e r g i l l i s @ a o l . c o m

7 3 7 n . a l f r e d s t r e e t # 2
l o s a n g e l e s , c a 9 0 0 6 9

DESIGN FIRM Gillis & Smiler
ART DIRECTORS/DESIGNERS Cheryl Gillis, Ellen Smiler
CLIENT Gillis & Smiler
TOOLS Adobe Illustrator
PAPER/PRINTING Neenah Classic Crest 3/1

HILDA G. LATORRE
Director of Marketing

Customized distribution for

the fragile and priceless

5105 Avalon Ridge Parkway

Norcross, Georgia 30071

Phone 404 263 6311

Toll Free 800 383 6311

Fax 404 242 1891

DESIGN FIRM Icehouse Design
ART DIRECTOR Pattie Belle Hastings
DESIGNER Bjourn Akselsen
CLIENT Graebel Fine Art
TOOLS Power Macintosh 8100

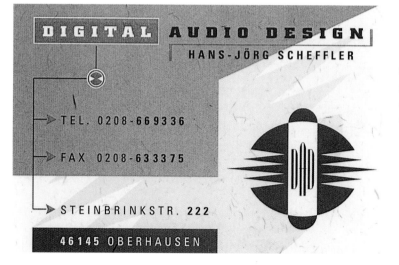

DESIGN FIRM Design Ahead
DESIGNER Ralf Stumpf
CLIENT Digital Audio Design
TOOLS Macromedia FreeHand, Macintosh

DESIGN FIRM W.P.C.G.—Gómez Chica
ALL DESIGN Juan José Posada
CLIENT Librería del Parque
TOOLS Adobe Illustrator, Power Macintosh 7100
PAPER/PRINTING Kimberly

DESIGN FIRM DJB Designs
DESIGNER/ILLUSTRATOR Daniel J. Bretz
CLIENT Gayle Spletstober
TOOLS Adobe Photoshop, Adobe Illustrator
PAPER/PRINTING Simpson Quest 80 lb./Two-color litho

DESIGN FIRM McGaughy Design
ART DIRECTOR/DESIGNER Malcolm McGaughy
CLIENT DSS Company
TOOLS Macromedia FreeHand
PAPER/PRINTING Speckletone Old Green/Three-color

DESIGN FIRM Duck Soup Graphics
ART DIRECTOR/DESIGNER
William Doucette
CLIENT Brown Bag Cookie Company
TOOLS Adobe Illustrator, QuarkXPress
PAPER/PRINTING French
Speckletone/Two match colors

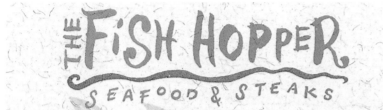

700 Cannery Row • Monterey, CA 93940
Tel(408)372-8543 • Fax(408)372-2026

DESIGN FIRM On The Edge
ART DIRECTOR/ILLUSTRATOR Jeff Gasper
DESIGNER Gina Mims
CLIENT The Fish Hopper
TOOLS Adobe Illustrator, QuarkXPress
PAPER/PRINTING Evergreen Natural

arenal pictures

1923 Arenal Road SW
Albuquerque
New Mexico
87105-4045

Tel/Fax: 505. 877.1382

Kevin Richard Lee

DESIGN FIRM LSL Industries
DESIGNERS Franz M. Lee,
Elisabeth Spitalny
ILLUSTRATOR Franz M. Lee
CLIENT Arenal Pictures
TOOLS QuarkXPress, PowerDraw
PAPER/PRINTING French
Newsprint White

Jan **Clancy**
GENERAL MANAGER

ST MARTINS
YOUTH ARTS CENTRE
28 St Martins Lane, South Yarra. 3141
03) 9867 2477
FAX: (03) 9866 2733

DESIGN FIRM
Storm Design & Advertising Consultancy
ART DIRECTORS/DESIGNERS
Dean Butler, David Ansett
ILLUSTRATOR
Dean Butler
CLIENT
St. Martins Youth Art Centre
PAPER/PRINTING
Raleigh Paper Co. stock/
Two PMS colors (black and metallic)

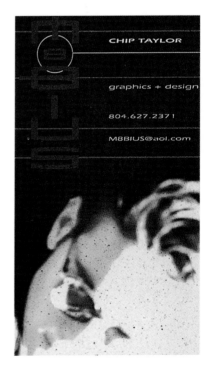

DESIGN FIRM Möbius
ALL DESIGN Chip Taylor
CLIENT Chip Taylor
TOOLS Power Macintosh 8500,
Adobe Photoshop, Adobe Illustrator
PAPER/PRINTING Quest/Offset

CAROL J. MCCUTCHEON

GENERAL, COSMETIC & FAMILY DENTIS

Dr. Carol

CAROL MCCUTCHEON, D.D.S, INC.
621 EAST CAMPBELL AVE. SUITE 18
CAMPBELL, CA 95008
408/379-0851 FAX 378-7515

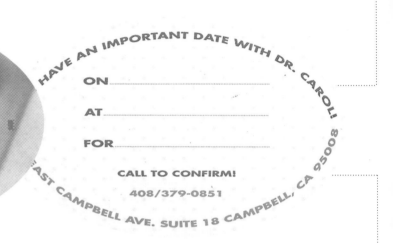

HAVE AN IMPORTANT DATE WITH DR. CAROL!

ON _____

AT _____

FOR _____

CALL TO CONFIRM!
408/379-0851

EAST CAMPBELL AVE. SUITE 18 CAMPBELL, CA 95008

YOU HAVE AN IMPORTANT
DATE WITH DR. CAROL!

ON _____

AT _____

FOR _____

CALL TO CONFIRM! 408/379-0851

621 EAST CAMPBELL AVE. SUITE 18

CAMPBELL, CA 95008

DESIGN FIRM Aerial
ART DIRECTOR/DESIGNER Tracy Moon
CLIENT Carol J. McCutcheon, DDS
TOOLS QuarkXPress, Adobe Photoshop, Adobe Illustrator
PAPER/PRINTING Strathmore Bright White Dots

Barbara Wallich
Account Coordinator

250 Ridge Road
Post Office Box 558
Dayton, New Jersey
Zip 08810.0558
Voice 908.274.2000
Fax 908.274.2417

Events

Marketing

Exhibits

Interiors

On Site Services

Events

Marketing

Exhibits

Interiors

On Site Services

Heather Caruso
Graphics Coordinator

250 Ridge Road
Post Office Box 558
Dayton, New Jersey
Zip 08810.0558
Voice 908.274.2000
Fax 908.274.2417

Joseph DeAmbrose
Designer

250 Ridge Road
Post Office Box 558
Dayton, New Jersey
Zip 08810.0558
Voice 908.274.2000
Fax 908.274.2417

DESIGN FIRM Aerial
ART DIRECTOR/DESIGNER Tracy Moon
CLIENT Impact
TOOLS Adobe Illustrator, QuarkXPress

Events

Marketing

Exhibits

Interiors

On Site Services

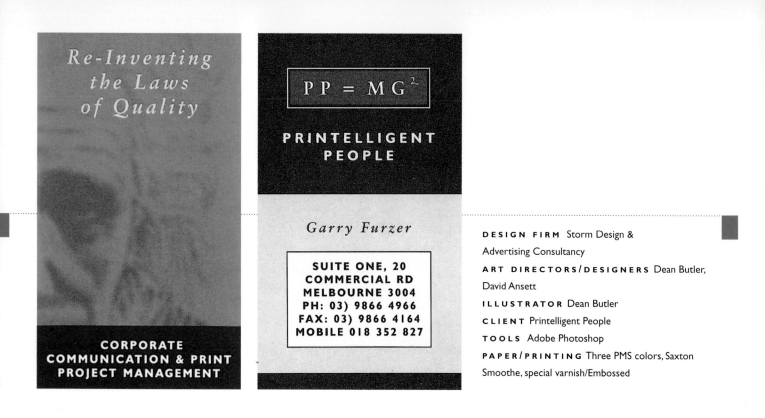

Re-Inventing the Laws of Quality

CORPORATE
COMMUNICATION & PRINT
PROJECT MANAGEMENT

$PP = MG^2$

PRINTELLIGENT
PEOPLE

Garry Furzer

SUITE ONE, 20
COMMERCIAL RD
MELBOURNE 3004
PH: 03) 9866 4966
FAX: 03) 9866 4164
MOBILE 018 352 827

DESIGN FIRM Storm Design & Advertising Consultancy
ART DIRECTORS/DESIGNERS Dean Butler, David Ansett
ILLUSTRATOR Dean Butler
CLIENT Printelligent People
TOOLS Adobe Photoshop
PAPER/PRINTING Three PMS colors, Saxton Smoothe, special varnish/Embossed

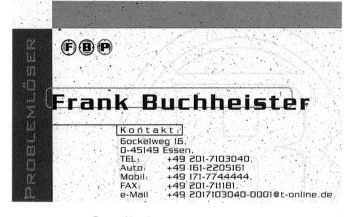

DESIGN FIRM Design Ahead
DESIGNER Theo Decker
CLIENT Frank Buchheister
TOOLS Macromedia FreeHand, Macintosh

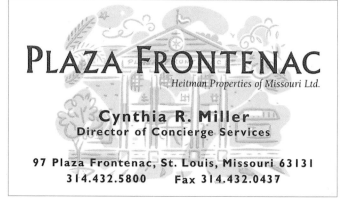

DESIGN FIRM Kiku Obata & Company
ART DIRECTOR Pam Bliss
DESIGNER John Schetel
CLIENT Plaza Frontenac
PAPER/PRINTING Reprox

DESIGN FIRM Gackle Anderson Henningsen, Inc.
DESIGNER Jason Bramer
CLIENT Gackle Anderson Henningsen, Inc.
TOOLS QuarkXPress, Adobe Illustrator

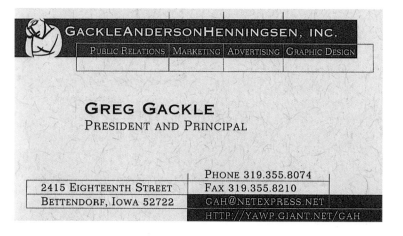

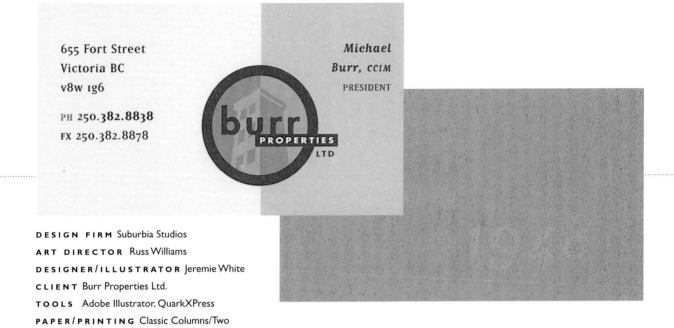

655 Fort Street
Victoria BC
v8w 1g6

PH 250.382.8838
FX 250.382.8878

Michael
Burr, CCIM
PRESIDENT

DESIGN FIRM Suburbia Studios
ART DIRECTOR Russ Williams
DESIGNER/ILLUSTRATOR Jeremie White
CLIENT Burr Properties Ltd.
TOOLS Adobe Illustrator, QuarkXPress
PAPER/PRINTING Classic Columns/Two
color one side, one color one side

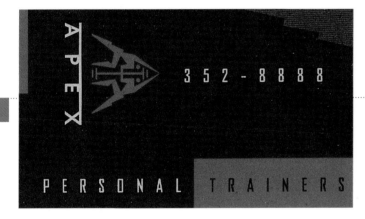

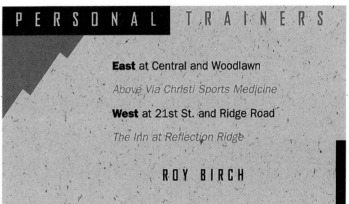

DESIGN FIRM Greteman Group
ART DIRECTOR Sonia Greteman
DESIGNERS Sonia Greteman, James Strange
CLIENT Apex
TOOLS Macromedia FreeHand
PAPER/PRINTING Genesis/Two-color offset

DESIGN FIRM Bruce Yelaska Design
ART DIRECTOR/DESIGNER Bruce Yelaska
CLIENT La Rotonda sul Mare
TOOLS Adobe Illustrator
PAPER/PRINTING Strathmore Writing/Offset

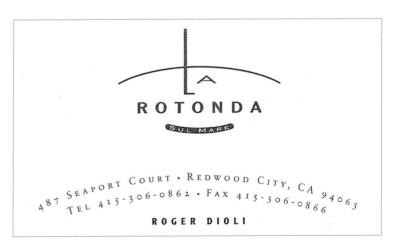

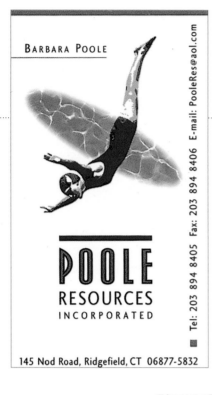

BARBARA POOLE

POOLE
RESOURCES
INCORPORATED

Tel: 203 894 8405 Fax: 203 894 8406 E-mail: PooleRes@aol.com

145 Nod Road, Ridgefield, CT 06877-5832

IT'S WHAT YOU'VE GOT INSIDE.

DESIGN FIRM Cahoots
ART DIRECTOR Carol Lasky
DESIGNER/ILLUSTRATOR Kerri Bennett
CLIENT Poole Resources
TOOLS Macromedia FreeHand, QuarkXPress, Adobe Photoshop
PAPER/PRINTING The Ink Spot

DESIGN FIRM
Sayles Graphic Design
ALL DESIGN
John Sayles
CLIENT
Rae Simonini Hildreth
PAPER/PRINTING
Hopper Nekosah feltweave parchment/Offset

HAIR DESIGNER

NAIL TECHNICIAN

THE UPPER CUT
118 FIFTH STREET
VALLEY JUNCTION
WEST DES MOINES
255-0704
276-9084

RAE
SIMONINI
HILDRETH

YOUR NEXT APPOINTMENT WITH RAE IS:

DESIGN FIRM Heart Graphic Design
ART DIRECTOR/DESIGNER Clark Most
CLIENT Graphx Plus Printers
TOOLS Adobe Photoshop, QuarkXPress

GRAFXPLUS
INCORPORATED

Lonnie Campbell

105 N. 4th

P.O. Box 479

Coleman, MI 48618

Phone: 517-465-6916

Fax: 517-465-6800

GRAFXPLUS
INCORPORATED

Lonnie Campbell

105 N. 4th

P.O. Box 479

Coleman, MI 48618

Phone: 517-465-6916

Fax: 517-465-6800

GRAFXPLUS
INCORPORATED

Lonnie Campbell

105 N. 4th

P.O. Box 479

Coleman, MI 48618

Phone: 517-465-6916

Fax: 517-465-6800

Michael M. Trager

Mason Charles Design

147 West 38th Street

Phone (888) MCD-9386

New York, NY 10018

Fax (212) 719-4471

MCDTrager@aol.com

MCD
Design

Graphic
Design
Corporate
Identity
Advertising
Design
Illustration
Promotions
Custom
Printing
Print
Management

DESIGN FIRM
Mason Charles Design
ART DIRECTOR/DESIGNER
Jeffrey Speiser
CLIENT
Mason Charles Design
TOOLS
QuarkXPress,
Adobe Illustrator
PAPER/PRINTING
Neenah Classic Columns Duplex
cover flat/Foil

DESIGN FIRM
Foco Media Digital Media Design &
Production GmbH. & Cie.
ART DIRECTOR/DESIGNER
Steffen Janus
CLIENT
Foco Media Digital Media Design &
Production GmbH. & Cie.
TOOLS
Adobe Photoshop, QuarkXPress
PAPER/PRINTING
Luxosatin 300gsm; Two-color offset

foco media

DESIGN FIRM Tanagram
DESIGNER/ILLUSTRATOR Anthony Ma
CLIENT Lankmar Corp.
TOOLS Macromedia FreeHand

LANKMAR
corporation

Alan E. Baltis president
4602 mumford drive | suite 110 | hoffman estates, illinois
ph.708.202.1919 | fax.708.359.8385 | 60195-1110

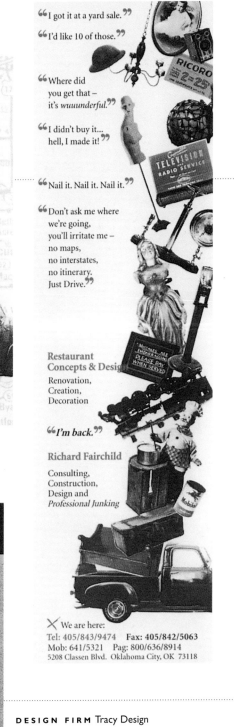

DESIGN FIRM
Val Gene Associates
DESIGNER Lacy Leverett
PRODUCTION Morrow Design
CLIENT Restaurant Concepts & Design
PAPER/PRINTING Baker's Printing

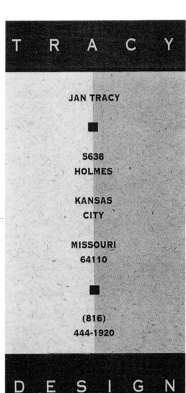

DESIGN FIRM Tracy Design
ART DIRECTOR Jan Tracy
DESIGNERS Jan Tracy, Jason Lilly
CLIENT Tracy Design
PAPER/PRINTING Black on Duplex "Environment"

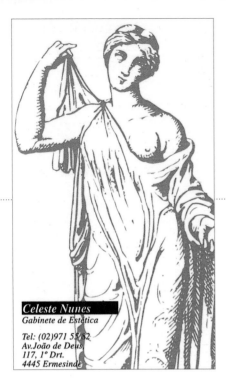

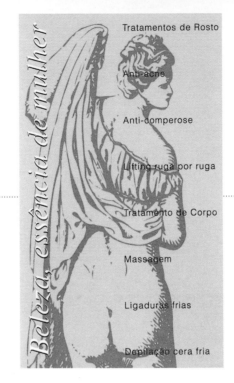

DESIGN FIRM
MA&A—Mário Aurélio & Associados
ART DIRECTOR Mário Aurélio
DESIGNERS Mário Aurélio, Rosa Maia
CLIENT Celeste Nunes/Gabinete
de Etética

DESIGN FIRM Barbara Brown Marketing & Design
CREATIVE DIRECTOR/DESIGNER Barbara Brown
ILLUSTRATOR Darthe Silver (digital design)
CLIENT Regional Management Inc.

DESIGN FIRM Elena Design
ART DIRECTOR/DESIGNER Elena Baca
CLIENT Wendy Thomas
TOOLS QuarkXPress, Adobe Photoshop
PAPER/PRINTING French Speckeltone

DESIGN FIRM Shields Design
ART DIRECTOR/DESIGNER Charles Shields
CLIENT Phil Rudy Photography
TOOLS Adobe Illustrator, Adobe Photoshop
PAPER/PRINTING Strathmore Elements
Soft White Dots/Offset

DESIGN FIRM Sagmeister, Inc.

ALL DESIGN Stefan Sagmeister

CLIENT Armin Schneider

PAPER/PRINTING Strathmore Writing 25% cotton

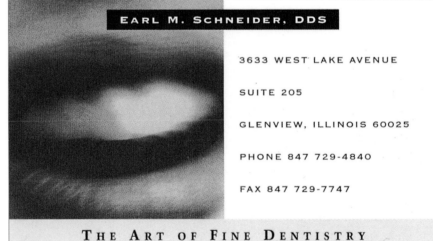

DESIGN FIRM
Borchew Design Group, Inc.
ART DIRECTOR/DESIGNER
Anne Bahan
CLIENT
Earl Schneider, DDS
TOOLS
QuarkXPress, Adobe Photoshop
PAPER/PRINTING
Neenah Classic Columns

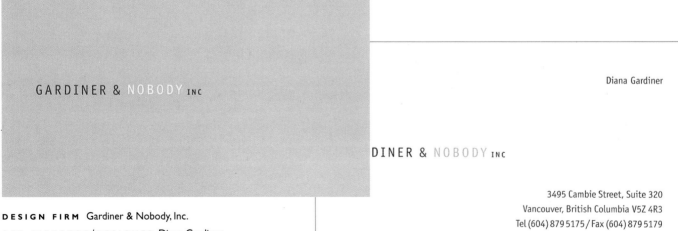

DESIGN FIRM Gardiner & Nobody, Inc.

ART DIRECTOR/DESIGNER Diana Gardiner

CLIENT Gardiner & Nobody, Inc.

TOOLS QuarkXPress, Adobe Illustrator

PAPER/PRINTING Strathmore Writing

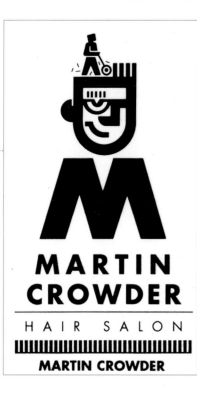

MARTIN CROWDER

HAIR SALON

MARTIN CROWDER

5709 HICKMAN ROAD
DES MOINES, IOWA 50310
515-277-1709

YOUR APPOINTMENT IS:

DESIGN FIRM Sayles Graphic Design
ALL DESIGN John Sayles
CLIENT Martin Crowder Hair Salon
PAPER/PRINTING Springhill tag coated one side/Offset

ANDREW M. LAURIA

RESOLVE CONSULTING

11 MOSS HILL LANE

LAGUNA HILLS, CA 92653

714.770.7741

FAX.770.7784

RE solve

REAL ESTATE PROJECT MANAGEMENT

DESIGN FIRM Vrontikis Design Office
ART DIRECTOR Petrula Vrontikis
DESIGNER Kim Sage
CLIENT Resolve Consulting
PAPER/PRINTING Neenah Classic Crest

11718 Barrington Ct. Suite 1
Los Angeles, California 900

PH 310.203.4993 FX 310.476.64
E-MAIL robert@greenhood.c

Robert C. Greenhood

DESIGN FIRM Vrontikis Design Office
ART DIRECTOR Petrula Vrontikis
DESIGNER Samuel Lising
CLIENT Greenhold and Company
PAPER/PRINTING Duratone/rubber stamp
and laser printing

DESIGN FIRM Design Ahead
DESIGNER Ralf Stumpf
CLIENT Fritzen & Partner
TOOLS Macromedia FreeHand, Macintosh

FRITZEN & PARTNER
EDV ORGANISATION

NORBERT GRECHZA Blumenstraße 74
47798 Krefeld
Fon (02151) 787073

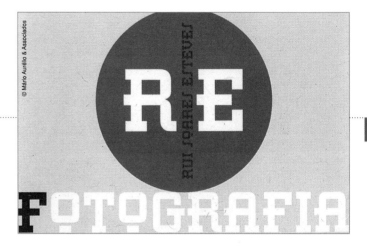

DESIGN FIRM MA&A—Mário Aurélio & Associados
ART DIRECTOR Mário Aurélio
DESIGNERS Mário Aurélio, Rosa Maia
CLIENT Rui Soares Esteves/Fotografia

DESIGN FIRM Mires Design
ART DIRECTOR John Ball
DESIGNERS John Ball, Miguel Perez
CLIENT Verde Communications

6170 Cornerstone Court East, Suite 380 San Diego, CA 92121
ph:619 622 1411 fx:619 622 1214 e-mail:csimunec@verdestyle.com
http://www.verdestyle.com

Cindy Simunec
Vice President, Sales and Marketing

DESIGN FIRM Mires Design
ART DIRECTOR John Ball
DESIGNERS John Ball, Miguel Perez
CLIENT Mires Design
PAPER/PRINTING Gilbert Correspond
heavy watercolor board

MIRES DESIGN INC

2345 KETTNER BLVD SAN DIEGO CA 92101

PHONE: 619 234 6631 FAX: 619 234 1807

E MAIL: MIRES@MIRESDESIGN.COM

SCOTT MIRES

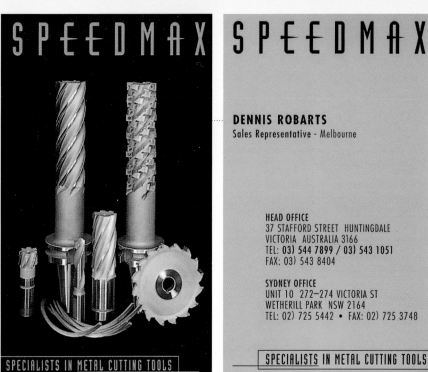

SPEEDMAX

DENNIS ROBARTS
Sales Representative - Melbourne

HEAD OFFICE
37 STAFFORD STREET HUNTINGDALE
VICTORIA AUSTRALIA 3166
TEL: 03) 544 7899 / 03) 543 1051
FAX: 03) 543 8404

SYDNEY OFFICE
UNIT 10 272–274 VICTORIA ST
WETHERILL PARK NSW 2164
TEL: 02) 725 5442 • FAX: 02) 725 3748

SPECIALISTS IN METAL CUTTING TOOLS

DESIGN FIRM
Mammoliti Chan Design
ART DIRECTOR/DESIGNER
Tony Mammoliti
CLIENT Speeedmax
TOOLS Adobe Illustrator, QuarkXPress
PAPER/PRINTING Four-color plus
two PMS reverse

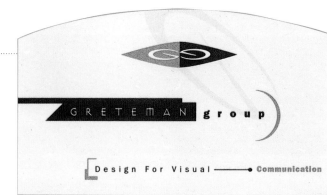

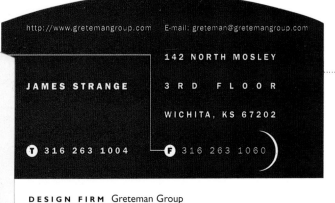

DESIGN FIRM Greteman Group
ART DIRECTOR Sonia Greteman
DESIGNERS Sonia Greteman, James Strange
CLIENT Greteman Group
TOOLS Macromedia FreeHand
PAPER/PRINTING Conquest/Two-color offset

DESIGN FIRM Nancy Yeasting Design & Illustration
ALL DESIGN Nancy Yeasting
CLIENT Zoey Ryan
TOOLS Brush, QuarkXPress
PAPER/PRINTING Genesis husk/One color

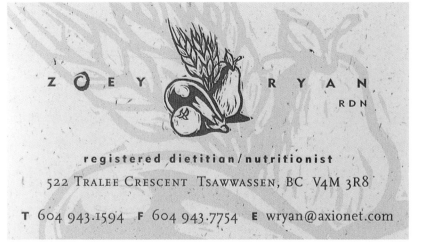

DESIGN FIRM
The Design Company
ART DIRECTOR
Marcia Romanuck
DESIGNER/ILLUSTRATOR
Alison Scheel
CLIENT
Snelling Real Estate
PAPER/PRINTING
Champion Carnival 80 lb. Ivory

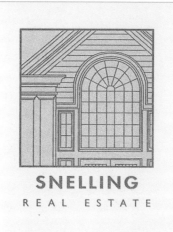

SNELLING
REAL ESTATE

Kelly Snelling
770-926-9909

Mailing Address:
1034 Longwood Drive
Woodstock, GA 30189

Broker:
770-926-9909

E-mail:
snellingrealestate@usa.net

SANDRA KIMBALL
PHOTOGRAPHY

P.O. Box 274 Hamilton, MA 01936 Tel 508 468 4480 Fax 508 468 1604

DESIGN FIRM Cahoots
ART DIRECTOR Carol Lasky
DESIGNERS Kerri Bennett, Laura Herrmann
ILLUSTRATOR Richard Goldberg
CLIENT Sandra Kimball Photography
TOOLS Macromedia FreeHand, QuarkXPress
PAPER/PRINTING Curtis Brightwater

DESIGN FIRM Sagmeister, Inc.
ART DIRECTOR/DESIGNER
Stefan Sagmeister
ILLUSTRATOR Veronica Oh
CLIENT Aguilar
PAPER/PRINTING Strathmore
Writing 25% cotton

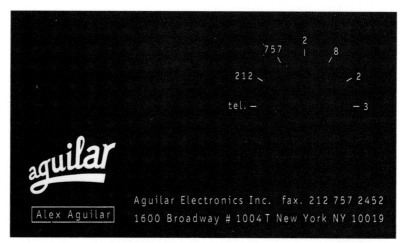

aguilar

Alex Aguilar

Aguilar Electronics Inc. fax. 212 757 2452
1600 Broadway # 1004T New York NY 10019

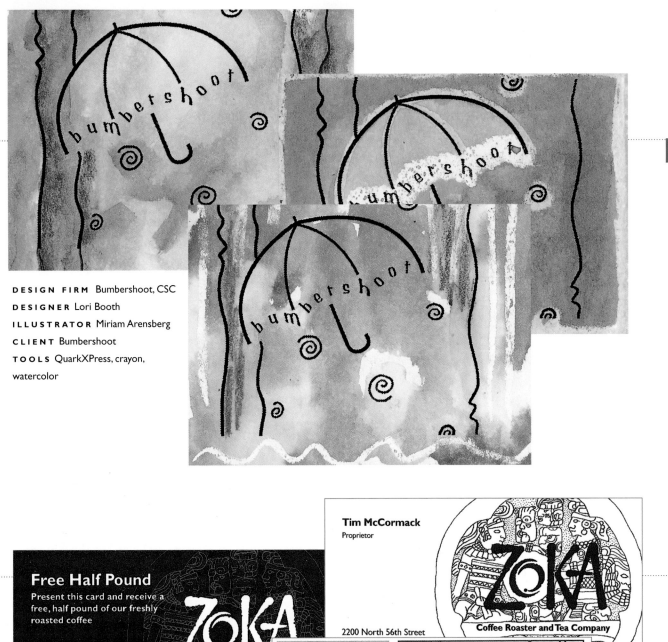

DESIGN FIRM Bumbershoot, CSC
DESIGNER Lori Booth
ILLUSTRATOR Miriam Arensberg
CLIENT Bumbershoot
TOOLS QuarkXPress, crayon, watercolor

Free Half Pound
Present this card and receive a free, half pound of our freshly roasted coffee

2200 North 56th Street
Seattle, Washington 98103
Telephone 206 545 4277
Facsimile 206 545 4278

ZOKA
Coffee Roaster and Tea C

Tim McCormack
Proprietor

2200 North 56th Street

ZOKA
Coffee Roaster and Tea Company

DESIGN FIRM Walsh and Associates, Inc.
ART DIRECTOR Miriam Lisco
DESIGNER Mark Ely
ILLUSTRATOR Iskra Johnson, calligrapher
CLIENT Zoka Coffee Roaster & Tea Company
TOOLS Adobe Illustrator, Adobe PageMaker
PAPER/PRINTING Classic Crest/Printercraft
Printing, two color

DESIGN FIRM Aerial
ART DIRECTOR/DESIGNER Tracy Moon
PHOTOGRAPHER R. J. Muna
CLIENT Aerial
TOOLS Adobe Photoshop, Live Picture, QuarkXPress

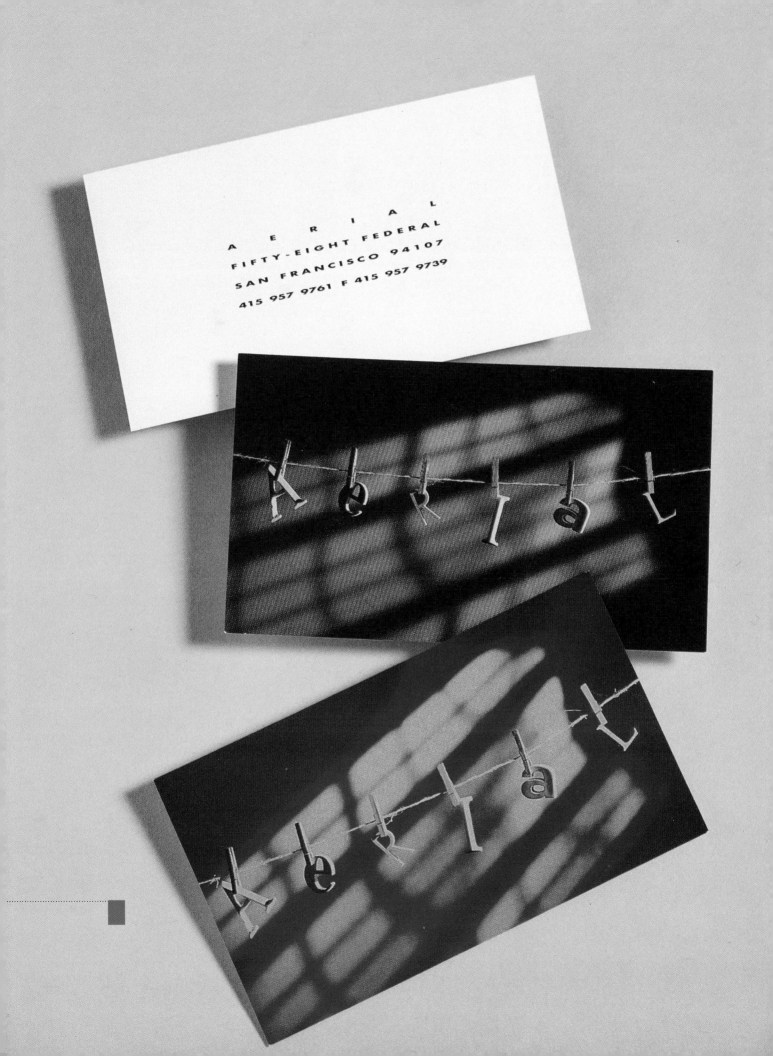

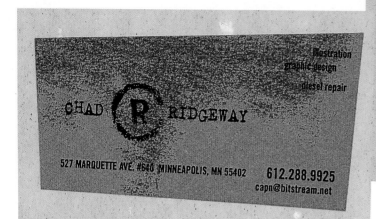

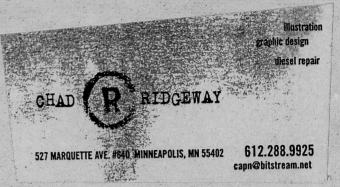

DESIGN FIRM CR Design
ALL DESIGN Chad Ridgeway
TOOLS Macintosh, Xerox, scissors
PAPER/PRINTING French packing carton,
construction paper

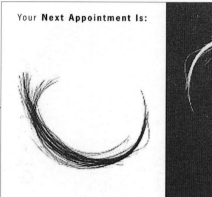

DESIGN FIRM Charney Design
ART DIRECTOR/DESIGNER Carol Inez Charney
PHOTOGRAPHER Carol Charney
CLIENT Leslie Vasquez
TOOLS QuarkXPress, Adobe Photoshop
PAPER/PRINTING Vintage/Offset

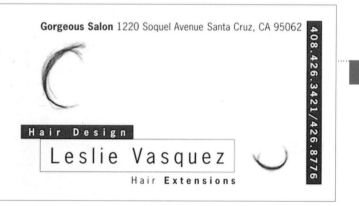

DESIGN FIRM A1 Design
ART DIRECTOR/DESIGNER Amy Gregg
CLIENT Peter Belanger Photography
TOOLS Macintosh Quadra 800, Adobe Illustrator
PAPER/PRINTING Letterpress

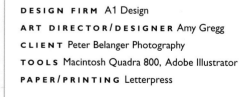

Peter Belanger Photography

2325 Third Street suite 343

San Francisco, California 94107

tel 415.554.0907 fax 415.554.0987

DESIGN FIRM JWK Design Group, Inc.

ART DIRECTOR Jennifer Kompolt

DESIGNERS/ILLUSTRATORS Jennifer Kompolt, Ian Nyquist

CLIENT NTT Multimedia Communications Laboratories

TOOLS Adobe Photoshop, Adobe Illustrator, QuarkXPress

PAPER/PRINTING Four-color offset

DESIGN FIRM A1 Design

DESIGNER Amy Gregg

CLIENT Badillo Consulting

TOOLS Macintosh Quadra 800, Adobe Illustrator

PAPER/PRINTING Strathmore 100% cotton/
Two-color offset

DESIGN FIRM Design Ranch

ART DIRECTOR/DESIGNER Gary Gnade

CLIENT Design Direction

PAPER/PRINTING Classic Crest/Linn Litho

29140 Buckingham Ave. Suite 5

Livonia, MI 48154

313 261-2001

Fax: 313 261-3282

email: epicnode@aol.com

12330 Conway Road

St. Louis, MO 63141

314 205-2266

Fax: 314 205-2540

National Outreach

Corbett Heimburger

National Outreach Director

Evangelical Presbyterian Church

DESIGN FIRM Jacque Consulting & Design
DESIGNER/ILLUSTRATOR Janelle Sayegh
CLIENT Evangelical Presbyterian Church
TOOLS Adobe FreeHand
PAPER/PRINTING Neenah Classic Crest

DESIGN FIRM 9 Volt Visuals
ART DIRECTOR/DESIGNER Bobby June
CLIENT 9 Volt Visuals
TOOLS Adobe Photoshop, Adobe Illustrator
PAPER/PRINTING Twin Concepts

DESIGN FIRM Elena Design
ART DIRECTOR/DESIGNER Elena Baca
CLIENT Wendy Thomas
TOOLS Adobe Photoshop, QuarkXPress
PAPER/PRINTING French Speckeltone

DESIGN FIRM Duck Soup Graphics
ART DIRECTOR/DESIGNER William Doucette
CLIENT Sunbaked Software
TOOLS Macromedia FreeHand, QuarkXPress
PAPER/PRINTING Circa select/
Two match colors, blowtorch

DESIGN FIRM Design Center
ART DIRECTOR John Reger
DESIGNER Sherwin Schwartzrock
CLIENT AvonLea
TOOLS Macintosh
PAPER/PRINTING Procraft Printing

DESIGN FIRM Mother Graphic Design
ALL DESIGN Kristin Thieme
CLIENT Art House

DESIGN FIRM Moos Design
ALL DESIGN Moos Kuppers
CLIENT Dennis Dwinger
TOOLS Macintosh, numbering by printer

Craig Webster

PO Box 344
Deer Harbor, WA 98243
Fax (360) 376-6091
Tel (360) 376-3037
VHF Channel 78

DESIGN FIRM Widmeyer Design
ART DIRECTORS Ken Widmeyer, Dale Hart
DESIGNER/ILLUSTRATOR Dale Hart
CLIENT Deer Harbor Marina
TOOLS Power Macintosh, Macromedia
FreeHand, Adobe Photoshop
PAPER/PRINTING Proterra Flecks/Offset

DESIGN FIRM Blue Suede Studios
ALL DESIGN Justin Baker
CLIENT Waisman Photography
PAPER/PRINTING Genesis/Hemlock Express

DESIGN FIRM Tharp Did It
ART DIRECTOR Rick Tharp
DESIGNERS Rick Tharp, Jana Heer
ILLUSTRATOR Georgia Deaver
CLIENT Yorkville Cellars
TOOLS Ink, traditional typography
PAPER/PRINTING Simpson Paper Company/Simon Printing

DESIGN FIRM Corridor Design
ART DIRECTOR/DESIGNER
Ejaz Saifullah
CLIENT Corridor Design
TOOLS Adobe Illustrator, QuarkXPress
PAPER/PRINTING French construction,
pure white/Rooney Printing Co.

suemaniangraphicdesign

broadcast
print
multimedia

broadcastprint**multimedia**

PAGE 800.963.4006
EMAIL SMANIAN@AOL.COM

niangraphicdesign

3133 CONNECTICUT AVE
SUITE 909 NW
WASHINGTON, DC 20008

DESIGN FIRM Imagine That, Inc.
ART DIRECTOR/DESIGNER Sue Manian
CLIENT Sue Manian Graphic Design
CLIENT Adobe Illustrator
PAPER/PRINTING Classic Crest/Clark's Litho

A

DESIGN FIRM Ameer Design
ART DIRECTOR/DESIGNER Janet Ameer
CLIENT Ameer Design

AMEER DESIGN 16 KEYES ROAD LONDON NW2 3XA

TELEPHONE AND FAX 0181 450 0464 **JANET AMEER**

apple graphics
& advertising, inc.

ALLISON SCHNEIDER

2314 merrick road

merrick, ny 11566

tel.: 516.868.1919

fax: 516.868.1982

apple graphics & advertising, inc.

DESIGN FIRM Apple Graphics & Advertising of Merrick, Inc.
DESIGNER Allison Blair Schneider
ILLUSTRATOR Michael Perez
CLIENT Apple Graphics
TOOLS Macromedia FreeHand, QuarkXPress,
Power Macintosh 7500
PAPER/PRINTING Fox River Circa Select Moss/Foil, offset

THE BEST OF BUSINESS CARD DESIGN 3 **61**

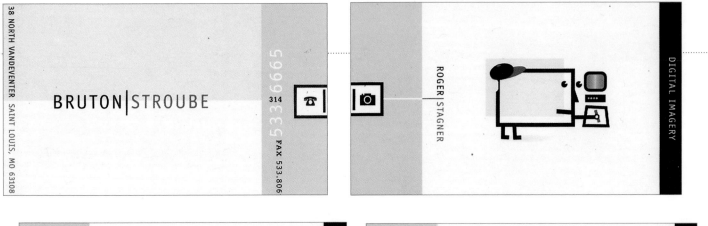

38 NORTH VANDEVENTER SAINT LOUIS, MO 63108

BRUTON|STROUBE

314 FAX 533.806 533.9995

DIGITAL IMAGERY — ROGER|STAGNER

STYLIST — CATHY|RAUCH

ASSISTANT PHOTOGRAPHER — BRIDGET|ANDERSON

SALES AND PRODUCTION — JENNIFER|CROGHAN

NAME ON DOOR — JON|BRUTON

SALES AND PRODUCTION — LISA MARIE|BARCOMB

DESIGN FIRM Phoenix Creative
ART DIRECTOR/DESIGNER Eric Thoelke
ILLUSTRATORS Eric Thoelke, Kathy Wilkinson
CLIENT Bruton/Stroube Studios
TOOLS QuarkXPress
PAPER/PRINTING Strathmore/Six PMS, two sides

RESTAURANT DESIGN
INTERIOR DESIGN
CONCEPT DEVELOPMENT
GRAPHIC DESIGN
MARKETING / ADVERTISING
TELEVISION / RADIO
COPYRIGHTING
BILLBOARD ADVERTISING
APPAREL DESIGN
FUND RAISING
PROMOTIONAL PRODUCTS
CHRISTIAN APPAREL
LOGO CREATION
TRADEMARKING
ANIMATION
WEB PAGE DESIGN
TRADITIONAL PAINTING
MURAL DESIGN
FULL COLOR PRINTING
SCREEN PRINTING
LARGE FORMAT PRINTING
DIGITAL PRINTING
PHOTO COPY
CD • JCARD DESIGN
PHONE BOOK AD DESIGN
SIGN PAINTING
BUMPER STICKERS
SCANNING
PHOTOGRAPHY
PHOTO RETOUCHING
COMPUTER TRAINING
MINOR COMPUTER REPAIR
AND SO MUCH MORE!

1.800.846.6263
2201 UNIVERSITY, LUBBOCK, TEXAS 79410

DESIGN FIRM Design Works Studio, Ltd.
ALL DESIGN Jason Vaughn
CLIENT Design Works Studio, Ltd.
TOOLS Adobe Photoshop, Adobe Illustrator, Adobe Dimensions
PAPER/PRINTING 10 pt. gloss/Four color

DESIGN FIRM Geffert Design
DESIGNER/ILLUSTRATOR Gerald Geffert
CLIENT Kees-Kieren/Weingut

DESIGN FIRM
Nagorny Design
ALL DESIGN
Andrey Nagorny
CLIENT
Hesed Biomed
TOOLS
Macromedia FreeHand
PAPER/PRINTING
Neenah Classic Laid/Two-color

Giles McCrary, Jr.

DreamTime
imagineering, inc.
3131 Turtle Creek Blvd. Suite 301
Dallas, TX 75219-5432
(214)526-3080•fax:(214)526-3084
dreamlab@aol.com

design@dreamlab.com

DreamTime Imagineering, Inc.

JILL HUTKO

3131 Turtle Creek Blvd, Suite 301

Dallas, Texas

75219-5432

214/526-3080

fax: 214/526-3084

dreamlab@aol.com

design@dreamlab.com

Mary Norvell
design@dreamlab.com

DreamTime
imagineering, inc.
3131 Turtle Creek Blvd. Suite 301
Dallas, TX 75219-5432
(214)526-3080•fax:(214)526-3084
dreamlab@aol.com

DESIGN FIRM DreamTime Imagineering, Inc.
ART DIRECTOR/DESIGNER Mary Norvell
TOOLS Adobe Photoshop, Adobe Illustrator
PAPER/PRINTING Strathmore Elements/
Knight Graphics

TECNOLOGIA
AMBIENTE,
LDA

Lucilia Pêgo (eng.)
consultora

CPQ

Rua Antero Quental, 236, s/211
Freixieiro
4450 Matosinhos
Telef:(02)9966401
Fax:(02)9966391

DESIGN FIRM MA&A—Mário Aurélio & Associados
ART DIRECTOR Mário Aurélio
DESIGNERS Mário Aurélio, Rosa Maia
CLIENT CPQ/Tecnologia Ambiente, Lda.

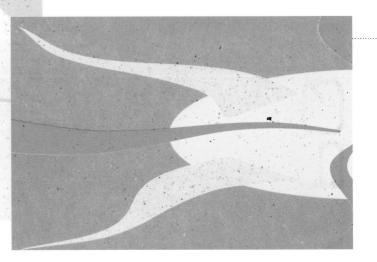

DESIGN FIRM Futura
ART DIRECTOR Igor Arih
DESIGNER Ermin Mededovic
CLIENT Futura
PAPER/PRINTING Silk print on used offset plates

FUTURA
advertising agency

Livarska 12,
1000 Ljubljana, Slovenija
tel: +386 61 1334 269, 1334 178
fax: +386 61 320 886
e mail: agency@futura.si

Maja Gspan Vičič
art director

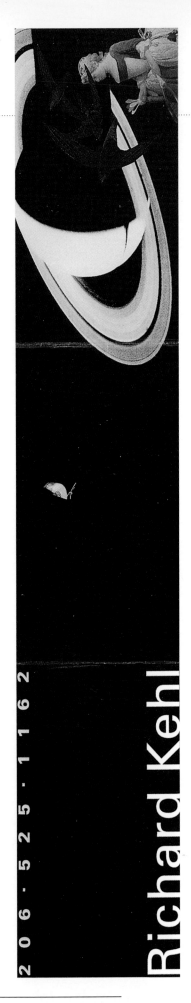

2 0 6 · 5 2 5 · 1 1 6 2

Richard Kehl

DESIGN FIRM Rick Eiber Design (RED)

ART DIRECTOR/DESIGNER Rick Eiber

CLIENT Sam A. Angeloff

TOOLS Macintosh

PAPER/PRINTING Cougar/Four-color process over black

DESIGN FIRM Lynn Wood Design

ART DIRECTOR/DESIGNER Lynn Wood

CLIENT Floyd Johnson

TOOLS QuarkXPress, Adobe Illustrator

PAPER/PRINTING Benefit

DESIGN FIRM 9 Volt Visuals

ART DIRECTOR/DESIGNER Bobby June

CLIENT 23 Skateboards

TOOLS Adobe Illustrator

PAPER/PRINTING Twin Concepts

Mazy Asky
assistant restaurant manager

• • •

telephone 214.922.1260 pager 214.848.0005
facsimile 214.922.1381 www.dani1717.com
dallas museum of art • seventeen seventeen restaurant
1717 n. harwood street dallas, texas 75201

SEVENTEEN SEVENTEEN
RESTAURANT

world class cuisine

DESIGN FIRM David Carter Design
ART DIRECTORS Sharon LeJeune, Randall Hill
DESIGNER Sharon LeJeune
ILLUSTRATOR Tracy Huck
CLIENT Dani, Kent Rathbun

DESIGN FIRM Judy Kahn
DESIGNER Judy Kahn
CLIENT Judy Kahn
TOOLS Adobe Illustrator
PAPER/PRINTING Champion Benefit
Vertical 80 lb. cover/Cactus

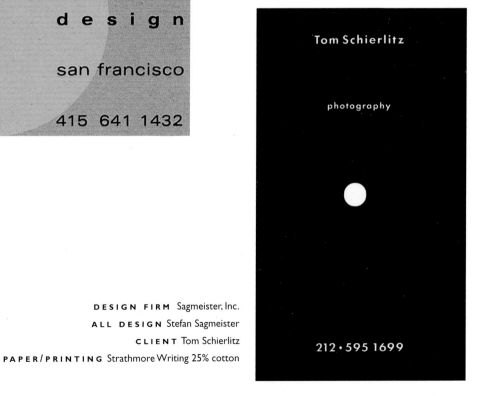

DESIGN FIRM Sagmeister, Inc.
ALL DESIGN Stefan Sagmeister
CLIENT Tom Schierlitz
PAPER/PRINTING Strathmore Writing 25% cotton

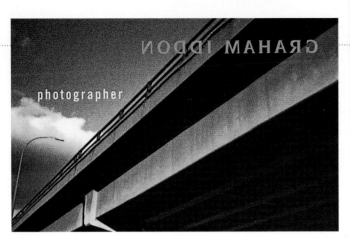

GRAHAM IDDON

photographer

365 Roncesvalles Avenue unit 127 Toronto Ontario
M6R 2M8 T 416.523.7362 E-M iddon@interlog.com

DESIGN FIRM Teikna
ART DIRECTOR/DESIGNER Claudia Neri
PHOTOGRAPHER Graham Iddon
CLIENT Graham Iddon
TOOLS QuarkXPress
PAPER/PRINTING Strathmore Elements/Two color

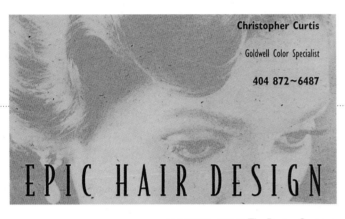

Christopher Curtis

Goldwell Color Specialist

404 872~6487

EPIC HAIR DESIGN

Expert Hair Care for Men & Women

featuring GOLDWELL

Hair Color & Permanent Waves

The Georgian Terrace

659 Peachtree St., Suite 500

Atlanta, GA 30308

DESIGN FIRM The Design Company
ART DIRECTOR Marcia Romanuck
CLIENT Epic Hair Design
PAPER/PRINTING Fraser Genesis Dawn 80 lb. cover

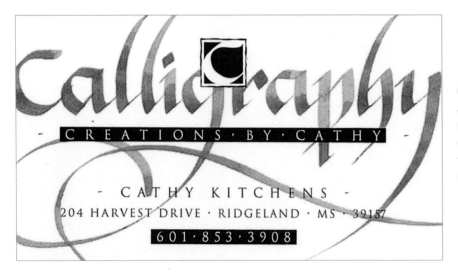

Calligraphy
- CREATIONS · BY · CATHY -
- CATHY KITCHENS -
204 HARVEST DRIVE · RIDGELAND · MS · 39157
601 · 853 · 3908

DESIGN FIRM Communication Arts Company
ART DIRECTOR/DESIGNER Mary Kitchens
ILLUSTRATOR Cathy Kitchens
CLIENT Creations by Cathy
TOOLS Calligraphy, pen, ink, Macintosh
PAPER/PRINTING Offset lithography

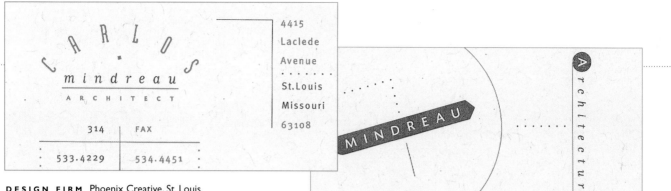

DESIGN FIRM Phoenix Creative, St. Louis
DESIGNER Ed Mantels-Seeker
CLIENT Carlos Mindreau, Architect
TOOLS Adobe Illustrator
PAPER/PRINTING Two-color litho

Duane Wood

WDG COMMUNICATIONS

3011 Johnson Avenue NW • Cedar Rapids, Iowa 52405
Telephone 319.396.1401 • Facsimile 319.396.1647

DESIGN FIRM WDG Communications
ALL DESIGN Duane Wood
CLIENT WDG Communications
TOOLS Pencil, paper, Adobe Illustrator, QuarkXPress
PAPER/PRINTING Neenah Classic Crest
Sawgrass 80 lb. cover/Cedar Graphics

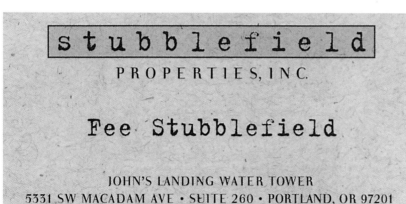

DESIGN FIRM Oakley Design Studios
ART DIRECTOR/DESIGNER Tim Oakley
CLIENT Stubblefield Properties
TOOLS QuarkXPress
PAPER/PRINTING Proterra flecks/Two color

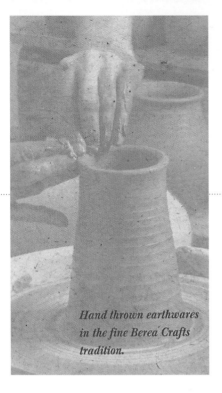

Hand thrown earthwares in the fine Berea Crafts tradition.

Tater Knob Pottery & Farm
Jeff Enge
Sarah Culbreth

260 Wolf Gap Road
Berea, Kentucky 40403
(606) 986 2167

DESIGN FIRM
Kirby Stephens Design, Inc.
ART DIRECTOR Kirby Stephens
DESIGNER/ILLUSTRATOR William V. Cox
CLIENT Tater Knob Pottery & Farm
TOOLS Pencil, Macintosh PPC, Camera, Adobe Photoshop, Macromedia FreeHand
PAPER/PRINTING Environment Recycled

OBJECT ENTERPRISES INCORPORATED

Jesse Tayler

OBJECT ENTERPRISES INCORPORATED
2608 2nd Avenue Suite 119
Seattle, WA 98121-1276 USA

Tel 206.217.0891
Fax 206.217.0394
Cel 206.954.3284

Jesse.Tayler@OEinc.com
www.oeinc.com

DESIGN FIRM Widmeyer Design
ART DIRECTORS Ken Widmeyer, Christopher Downs
DESIGNER Christopher Downs
ILLUSTRATOR Misha Melikov
CLIENT Object Enterprises, Inc.
TOOLS Power Macintosh, Adobe Photoshop, QuarkXPress
PAPER/PRINTING Mead Signature Satin/Four-color offset

DESIGN FIRM Melissa Passehl Design
ART DIRECTOR Melissa Passehl
DESIGNERS Melissa Passehl, Jill Steinfeld
CLIENT Alka Joshi Marketing

**ALKA JOSHI
MARKETING**

. .

Building Brands

Through Creative

Marketing

128 Middlefield Road, Palo Alto, CA 94301
Vox 415.326.7130 **Fax** 415.326.7044

DESIGN FIRM Widmeyer Design
ART DIRECTORS Ken Widmeyer, Dale Hart
DESIGNER Dale Hart
CLIENT Centris
TOOLS Power Macintosh, Macromedia FreeHand
PAPER/PRINTING Environment/Three-color offset

DESIGN FIRM Susan Guerra
ART DIRECTOR/DESIGNER Susan Guerra
CLIENT Robert Guerra
TOOLS Adobe Photoshop, Adobe Illustrator
PAPER/PRINTING One-color offset

DESIGN FIRM Able Design, Inc.
ART DIRECTORS Stuart Harvey Lee, Martha Davis
DESIGNER Martin Perrin
CLIENT Able Design
TOOLS Power Macintosh, QuarkXPress
PAPER/PRINTING Ikonofix 80 lb./Two-color printing, matte varnish

ON THE WALL

Mike Bascom

Painting, Finishing,
and Wallcoverings.

1054 North 39th St.
Seattle, WA 98103

Tel. (206) 632-4250
Fax (206) 632-9626

DESIGN FIRM
Rick Eiber Design (RED)
ART DIRECTOR/DESIGNER
Rick Eiber
ILLUSTRATORS
Cave Dweler, Gary Vock
CLIENT
On The Wall
PAPER/PRINTING
Speckletone/Two color

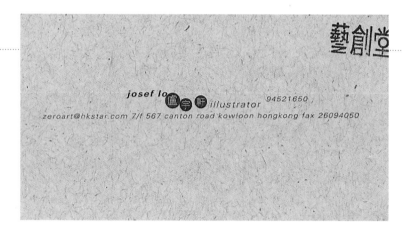

josef lo 盧宇軒 illustrator 94521650
zeroart@hkstar.com 7/f 567 canton road kowloon hongkong fax 26094050

DESIGN FIRM Zeroart Studio
ART DIRECTORS/DESIGNERS Lo Yu Hin, Josef
TOOLS Apple computer, Adobe Illustrator
PAPER/PRINTING 216 gsm recycled paper/Two spot colors
plus black, ink stamp

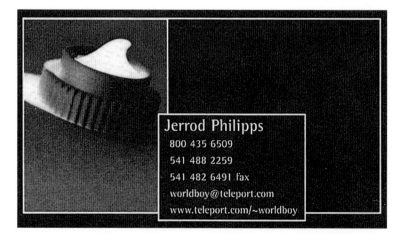

Jerrod Philipps
800 435 6509
541 488 2259
541 482 6491 fax
worldboy@teleport.com
www.teleport.com/~worldboy

DESIGN FIRM Blackfish Creative
ALL DESIGN Drew Force
CLIENT Jerrod Philipps Illustration
TOOLS QuarkXPress, Adobe Photoshop

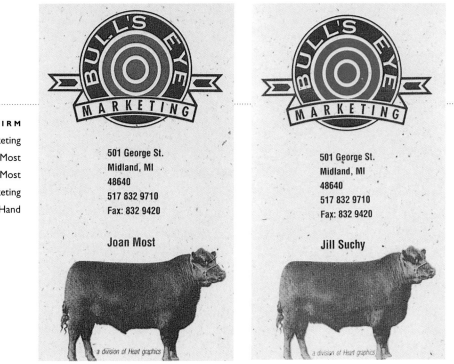

DESIGN FIRM
Heart Graphic Design/Bull's Eye Marketing
ART DIRECTOR Clark Most
DESIGNERS Clark Most, Joan Most
CLIENT Bull's Eye Marketing
TOOLS Macromedia FreeHand

501 George St.
Midland, MI
48640
517 832 9710
Fax: 832 9420

Joan Most

a division of Heart graphics

501 George St.
Midland, MI
48640
517 832 9710
Fax: 832 9420

Jill Suchy

a division of Heart graphics

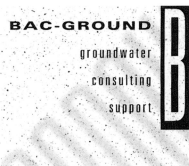

BAC-GROUND
groundwater
consulting
support
B

ernesto baca

3216 georgetown

houston texas 77005 usa

713.664.8452

ebaca@delphi.com

DESIGN FIRM Elena Design
ALL DESIGN Elena Baca
CLIENT Bac-Ground
TOOLS Adobe Illustrator, Adobe Photoshop
PAPER/PRINTING Simpson Quest

DESIGN FIRM Melissa Passehl Design
ART DIRECTOR Melissa Passehl
DESIGNERS Melissa Passehl,
Charlotte Lambrechts
CLIENT Melissa Passehl Design

MELISSA PASSEHL DESIGN CHARLOTTE LAMBRECHTS. DESIGNER

1275 LINCOLN AVE. #7. SAN JOSE. CA 95125. F 408.294.4104. T 408.294.4422.

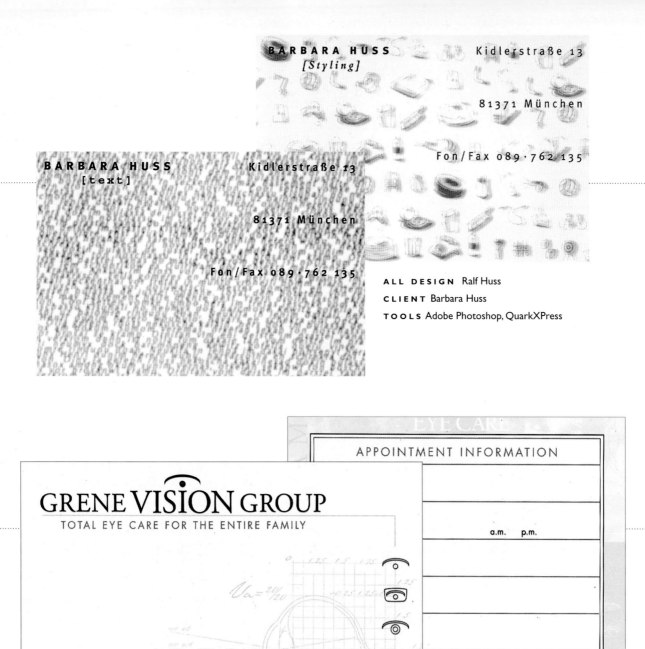

BARBARA HUSS
[Styling]

Kidlerstraße 13

81371 München

Fon/Fax 089·762 135

BARBARA HUSS
[text]

Kidlerstraße 13

81371 München

Fon/Fax 089·762 135

ALL DESIGN Ralf Huss
CLIENT Barbara Huss
TOOLS Adobe Photoshop, QuarkXPress

GRENE VISION GROUP
TOTAL EYE CARE FOR THE ENTIRE FAMILY

EYE CARE

APPOINTMENT INFORMATION

a.m. p.m.

PATIENT SERVICES 1 800 788 3060

DESIGN FIRM Insight Design Communications
ALL DESIGN Sherrie Holdeman, Tracy Holdeman
CLIENT Grene Vision Group
TOOLS Power Macintosh 7500, Macromedia FreeHand
PAPER/PRINTING Strathmore Bright White 80 lb. cover, text

DESIGN FIRM Stotts Design
ART DIRECTOR Helen Keel
DESIGNER Wendy Stott
ILLUSTRATOR Nicky Gissing
CLIENT Stotts
TOOLS Apple Macintosh, QuarkXPress, Adobe Photoshop
PAPER/PRINTING TL Visuals

s t o t t s
design management

Helen Keel MBA

18 Prior Park Buildings
Prior Park Road
Bath BA2 4NP

Tel: 01225 471102
Mobile: 0410 304177
Fax: 01225 471103

s t o t t s
design management

Helen Keel MBA

18 Prior Park Buildings
Prior Park Road
Bath BA2 4NP

Tel: 01225 471102
Mobile: 0410 304177
Fax: 01225 471103

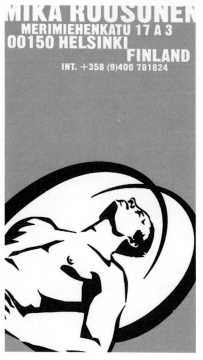

DESIGN FIRM M-DSIGN
ALL DESIGN Mika Ruusunen
CLIENT M-DSIGN
TOOLS Macintosh
PAPER/PRINTING Offset

DESIGN FIRM Melissa Passehl Design
ART DIRECTOR Melissa Passehl
DESIGNERS Melissa Passehl, Charlotte Lambrechts
CLIENT Paradise Printing

COMMERCIAL FURNITURE INTERIORS

DESIGN FIRM Toni Schowalter Design
ART DIRECTOR/DESIGNER Toni Schowalter
CLIENT Commercial Furniture Interiors
TOOLS Macintosh, QuarkXPress, Adobe Illustrator
PAPER/PRINTING Strathmore Writing/
Three-color offset, Soho Services

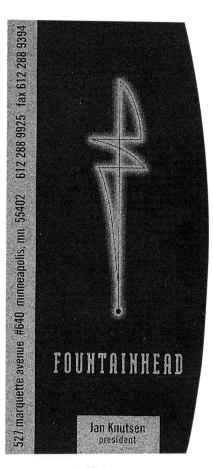

DESIGN FIRM CR Design
ART DIRECTOR Jan Knutsen
DESIGNER Chad Ridgeway
CLIENT Fountainhead
PAPER/PRINTING Antique Black
130 lb/Two color

MASSAGE THERAPY
436-3349

DESIGN FIRM Nancy Stutman Calligraphics
ALL DESIGN Nancy Stutman
CLIENT Sherman Adelman

TERPSICHORE

school of dance

Diane Danhieux
director

1011 Arthur Street
Iowa City, Iowa 52240

319.341.7833

DESIGN FIRM Design Ranch
ART DIRECTOR Gary Gnade
DESIGNERS Danette Angerer, Gary Gnade
CLIENT Terpsichore School of Dance
PAPER/PRINTING Wausau Royal
Fiber/Goodfellow Printing

12028 maidstone ave.

norwalk, ca. 90650

tel/fax
[562] 864.1181

éngTangdesign

GREEN CITY

Alexander Gröger

718 599 4867

65 South 8th St. #4
Brooklyn, NY 11211

DESIGN FIRM éng Tang Design
ART DIRECTOR/DESIGNER éng Tang
CLIENT éng Tang
TOOLS Adobe Illustrator

DESIGN FIRM Sagmeister, Inc.
ART DIRECTOR Stefan Sagmeister
DESIGNERS Stefan Sagmeister, Veronica Oh
ILLUSTRATOR Veronica Oh
CLIENT Green City
PAPER/PRINTING Strathmore Writing
25% cotton

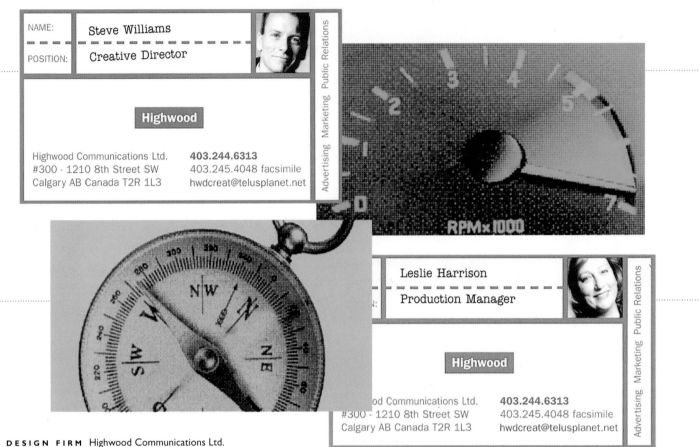

NAME: **Steve Williams**

POSITION: **Creative Director**

Advertising Marketing Public Relations

Highwood

Highwood Communications Ltd.
#300 - 1210 8th Street SW
Calgary AB Canada T2R 1L3

403.244.6313
403.245.4048 facsimile
hwdcreat@telusplanet.net

RPMx1000

Leslie Harrison

Production Manager

Advertising Marketing Public Relations

Highwood

...od Communications Ltd.
#300 - 1210 8th Street SW
Calgary AB Canada T2R 1L3

403.244.6313
403.245.4048 facsimile
hwdcreat@telusplanet.net

DESIGN FIRM Highwood Communications Ltd.
ART DIRECTOR Jeff Lennard
DESIGNER Darcy Parke
CLIENT Highwood Communications Ltd.
TOOLS QuarkXPress, Adobe Photoshop, Adobe Illustrator
PAPER/PRINTING Bravo Dull Cover/Phoenix Press

Mrs Anthony Lyle Skyrme
Director

LE MUR VIVANT

Gallery of Art

**30, Churton Street,
Belgrave Road,
London SW1V 2LP.
Tel./Fax. 0171-821 5555**

DESIGN FIRM Joyce Woollcott Designs
ALL DESIGN Joyce Woollcott
CLIENT Le Mur Vivant Art Gallery (The Living Wall)
TOOLS Adobe Illustrator

DESIGN FIRM Communication Design Maerz
ALL DESIGN Gabriele Maerz
CLIENT House of Hair, Vesna Messmer
TOOLS Brushstrokes, Macintosh
PAPER/PRINTING Fedrigoni Freelife/Two-color offset

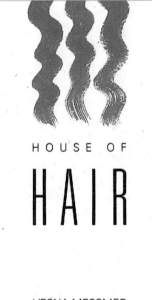

HOUSE OF

HAIR

VESNA MESSMER
WALLGUTSTR. 10
78462 KONSTANZ
TEL. 07531/21291

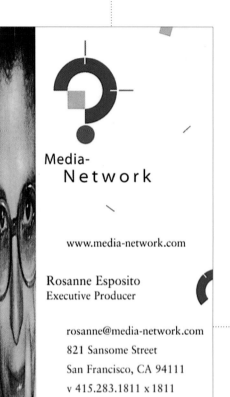

Media-
Network

www.media-network.com

Rosanne Esposito
Executive Producer

rosanne@media-network.com
821 Sansome Street
San Francisco, CA 94111
v 415.283.1811 x 1811
f 415.283.1801

Media-
Network

www.media-network.com

Cloude Porteus
IS Architect

cloude@media-network.com
821 Sansome Street
San Francisco, CA 94111
v 415.283.1811 x 1802
f 415.283.1801

Media-
Network

www.media-network.com

Hans Hartman
Executive Producer

hans@media-network.com
821 Sansome Street
San Francisco, CA 94111
v 415.283.1811 x 1888
f 415.283.1801

DESIGN FIRM Bruce Yelaska Design
ART DIRECTOR/DESIGNER Bruce Yelaska
CLIENT Media-Network
TOOLS Adobe Illustrator, Adobe Photoshop
PAPER/PRINTING Strathmore Writing/Offset

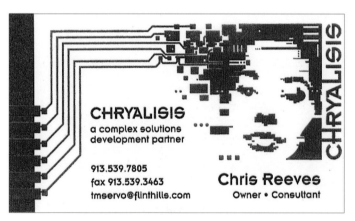

DESIGN FIRM S&N Design
ALL DESIGN Craig Goodman
CLIENT Chryalisis
TOOLS Adobe Illustrator
PAPER/PRINTING Neenah Classic Columns 120 lb.
cover/PMS 357, litho, matte copper foil

DESIGN FIRM Teikna
ART DIRECTOR/DESIGNER Claudia Neri
CLIENT Motion Pictures
TOOLS QuarkXPress, Adobe Photoshop
PAPER/PRINTING Arjowiggins/One color

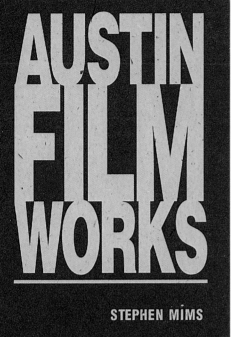

STEPHEN MIMS

902 EAST 5TH STREET
SUITE 211
AUSTIN, TEXAS 78702
VOICE: (512) 499-8809
FAX: (512) 472-5226

DESIGN FIRM
Kanokwalee Design
ART DIRECTOR/DESIGNER
Kanokwalee Lee
CLIENT
Austin Film Works
TOOLS
QuarkXPress
PAPER/PRINTING
Protera fleck

DESIGN FIRM
Gackle Anderson Henningsen, Inc.
DESIGNER
Wendy Anderson
CLIENT
Planet Audio
TOOLS
QuarkXPress, Adobe Illustrator
PAPER/PRINTING
Neenah Classic Laid
Solar White/Two PMS

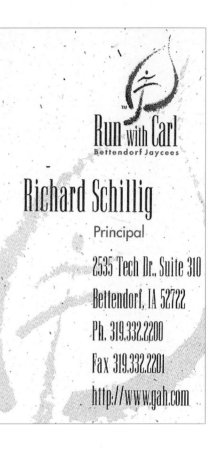

Run with Carl
Bettendorf Jaycees

Richard Schillig
Principal

2535 Tech Dr., Suite 310
Bettendorf, IA 52722
Ph. 319.332.2200
Fax 319.332.2201
http://www.gah.com

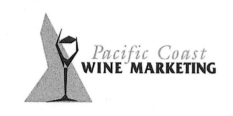

Pacific Coast
WINE MARKETING

16580 Harbor Blvd., Suite G • Fountain Valley, CA 92708

DESIGN FIRM Cordoba Graphics
ALL DESIGN éng Tang
CLIENT Pacific Coast
TOOLS Adobe Illustrator
PAPER PRINTING Flomar

DEBRA ROBERTS

15345 VIA SIMPATICO

AND ASSOCIATES

RANCHO SANTA FE

INCORPORATED

CALIFORNIA 92091

DEBRA J. ROBERTS, CFA

TEL 619-759-2649

PRESIDENT AND CEO

FAX 619-759-2653

DESIGN FIRM Mires Design
ART DIRECTOR Scott Mires
DESIGNERS Deborah Horn, Scott Mires
CLIENT Debra Roberts and Associates

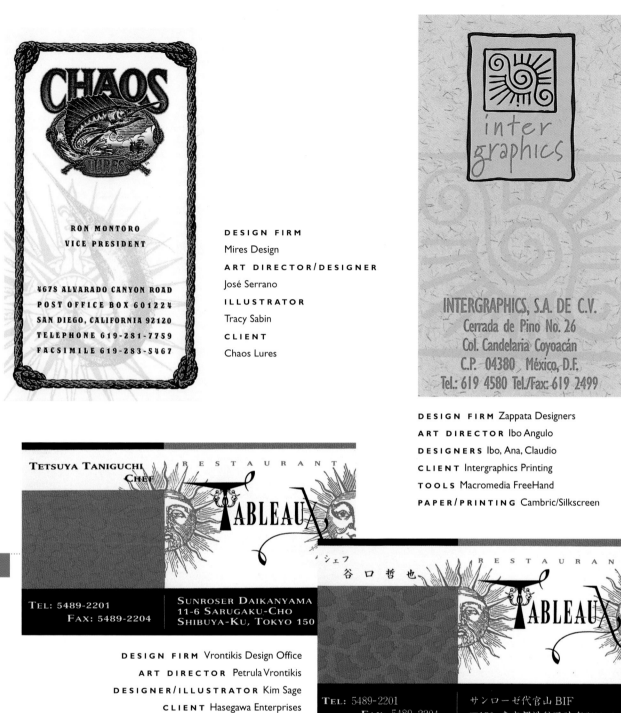

DESIGN FIRM
Mires Design
ART DIRECTOR/DESIGNER
José Serrano
ILLUSTRATOR
Tracy Sabin
CLIENT
Chaos Lures

DESIGN FIRM Zappata Designers
ART DIRECTOR Ibo Angulo
DESIGNERS Ibo, Ana, Claudio
CLIENT Intergraphics Printing
TOOLS Macromedia FreeHand
PAPER/PRINTING Cambric/Silkscreen

DESIGN FIRM Vrontikis Design Office
ART DIRECTOR Petrula Vrontikis
DESIGNER/ILLUSTRATOR Kim Sage
CLIENT Hasegawa Enterprises
PAPER/PRINTING Potlatch Korma/Four-color, Login Printing

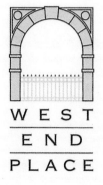

CINDY McGOURTY
Marketing Director

150 STANIFORD STREET
BOSTON, MA 02114
PHONE [617] 720-4646
FAX [617] 725-1888

DESIGN FIRM Phillips Design Group
ART DIRECTOR Steve Phillips
DESIGNER Alison Goudreault
CLIENT West End Place
TOOLS Adobe Illustrator
PAPER/PRINTING Strathmore
Natural White/Peacock Press

ed's
produce dept.

a design studio

élisabeth spitalny

P.O. Box 7788

Albuquerque, New Mexico 87194

505.260.2880

IQS
Innovative
Quality Service

MADE WITH PRIDE BY
ed

© 01 November 1994

DESIGN FIRM ed's produce dept.
DESIGNERS Donna Cohen,
Elizabeth Spitalny
CLIENT ed's produce dept.
TOOLS QuarkXPress, Adobe Photoshop
PAPER/PRINTING French Speckeltone, Kraft

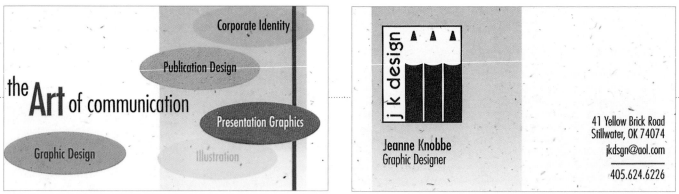

Corporate Identity

Publication Design

the **Art** of communication

Presentation Graphics

Graphic Design

Illustration

j k design

▲ ▲ ▲

Jeanne Knobbe
Graphic Designer

41 Yellow Brick Road
Stillwater, OK 74074
jkdsgn@aol.com

405.624.6226

DESIGN FIRM jk design
ALL DESIGN Jeanne Knobbe
CLIENT jk design
TOOLS Macromedia FreeHand
PAPER/PRINTING Hopper Protera Chalk/Three-color offset

GARRETT SOLOMON

▲ CHANNEL ISLANDS PROPERTIES

500 ESPLANADE DRIVE · SUITE 400

OXNARD CALIFORNIA 93030

PHONE 805·278·6600 FAX 805·278·6606

DESIGN FIRM Barbara Brown Marketing & Design
DESIGNER Barbara Brown
CLIENT Channel Islands Properties
PRINTING Ventura Printing

PHOTOGRAPHY 415/731-2524
JUSTIN CURTIS
1222 8th Avenue, San Francisco, CA 94122

PHOTOGRAPHY

DESIGN FIRM Charney Design
ART DIRECTOR/DESIGNER Carol Inez Charney
CLIENT Justin Curtis Photography
TOOLS QuarkXPress
PAPER/PRINTING Vintage/Offset

DeCurtis McMillan

Hair & Beauty

1497 YONGE STREET TORONTO, M4T 1Z2

TELEPHONE (416) 323 1739

DESIGN FIRM Teikna
ART DIRECTOR/DESIGNER Claudia Neri
CLIENT DeCurtis McMillan Hair Salon
TOOLS QuarkXPress
PAPER/PRINTING Roll and evolution/One color

To look and feel good

To take better care of each

other and our Planet

HAMILTON HOP ASSET MANAGEMENT GROUP

DESIGN FIRM Highwood Communications
ART DIRECTOR/DESIGNER Darcy Parke
CLIENT Hamilton Hop Asset Management Group
TOOLS Adobe Photoshop, QuarkXPress
PAPER/PRINTING Classic Crest cover

R. Darol Hamilton, CLU, Ch.F.C.,CFP
Principal
Estate • Succession • Retirement

1100, 734 - 7 Avenue S.W.
Calgary, Alberta T2P 3P8
Tel 403.262.2080
Fax 403.262.2074
www.hamilton-hop.com

still | moving | pictures

still | moving | pictures

still | moving | pictures

R J MUNA

PICTURES

GISELA HERMELING

225 INDUSTRIAL STREET
SAN FRANCISCO, CALIFORNIA
ZIP 94124-8975

415.468.8225 TEL
415.468.8295 FAX
pictures@rjmuna.com NET

DESIGN FIRM Aerial
ART DIRECTOR/DESIGNER
Tracy Moon
PHOTOGRAPHER R. J. Muna
CLIENT R. J. Muna Pictures
TOOLS Adobe Photoshop,
Adobe Illustrator, QuarkXPress
PAPER/PRINTING Strathmore
Natural White/Leewood Press

WENDY P. BASIL
EXEC. VICE PRESIDENT

HALSTED
COMMUNICATIONS
INC.

FONE
800.600.7111
X222
FAX
800.600.7112
E-MAIL
HALSTED@IX.NETCOM.COM

DESIGN FIRM Vrontikis Design Office
ART DIRECTOR Petrula Vrontikis
DESIGNER/ILLUSTRATOR Kim Sage
CLIENT Halsted Communications
PAPER/PRINTING Starwhite
Vicksburg Vellum/Two-color offset, Login Printing

DESIGN FIRM Aerial
ART DIRECTOR/DESIGNER Tracy Moon
PHOTOGRAPHER R. J. Muna
CLIENT Aerial
TOOLS Adobe Photoshop, Live Picture, QuarkXPress

KIKU OBATA

Cristina Hanssen

Kiku Obata & Company
5585 Pershing Avenue, Suite 240
St. Louis, Missouri 63112
Phone 314-361-3110
Fax 314-361-4716
kobata@aol.com

Cristina Hanssen

DESIGN FIRM Kiku Obata & Company
ART DIRECTOR/DESIGNER Rich Nelson
CLIENT Kiku Obata & Company
PAPER/PRINTING Reprox

TollFree

C e l l u l a r

Tony Howell
Operations Support Representative

900 Fourth Avenue
Suite 3400
Seattle, WA 98164

206.505.2233
206.505.2250 (F)
800.266.2125
tonyh@tollfree.com

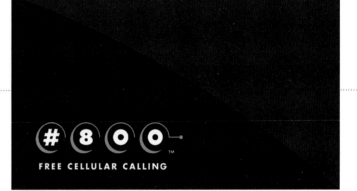

#800
FREE CELLULAR CALLING

DESIGN FIRM Hornall Anderson Design Works, Inc.
ART DIRECTOR John Hornall
DESIGNERS John Hornall, Heidi Favour, Jana Nishi,
Julie Lock, Mary Chin Hutchinson, Bruce Branson-Meyer
ILLUSTRATOR Jerry Nelson
CLIENT Toll-Free Cellular
TOOLS Macromedia FreeHand
PAPER/PRINTING Mohawk Superfine Eggshell white

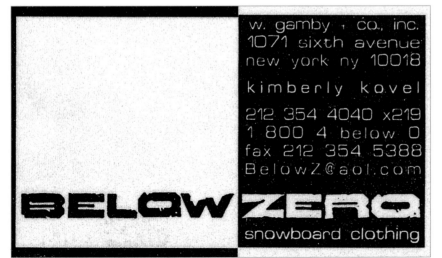

w. gamby , co., inc.
1071 sixth avenue
new york ny 10018
kimberly kovel
212 354 4040 x219
1 800 4 below 0
fax 212 354 5388
BelowZ@aol.com

BELOW ZERO
snowboard clothing

DESIGN FIRM Mason Charles Design
ART DIRECTOR Michael M. Trager
DESIGNER Terry Schindell
CLIENT Below Zero
PAPER/PRINTING Parchment/Thermography

DESIGN FIRM On The Edge
ART DIRECTOR/ILLUSTRATOR Jeff Gasper
DESIGNER Gina Mims
CLIENT Jillian's
TOOLS Adobe Illustrator, QuarkXPress, Adobe Photoshop
PAPER/PRINTING Mohawk White cover

DESIGN FIRM Donna Aikins Design
ART DIRECTOR/DESIGNER Donna Aikins
CLIENT Ingrid Tower
TOOLS CorelDraw, PC
PAPER/PRINTING Brilliant Art Gloss II 10 pt./Black ink

DESIGN FIRM Druvi Art & Design
ALL DESIGN Dhruvi Acharya
CLIENT Hindustran Pencils Ltd.
PAPER/PRINTING Embossed,
screen printing

KISHORE SANGHVI

HINDUSTAN PENCILS LIMITED.
510, HIMALAYA HOUSE, BOMBAY 400 001. TEL: 2614505,06,07,08.

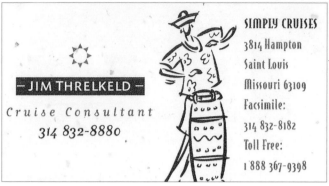

DESIGN FIRM Phoenix Creative

DESIGNER Ed Mantels-Seeker

CLIENT Simply Cruises

TOOLS QuarkXPress, Adobe Illustrator

PAPER/PRINTING Two-color litho with one color change

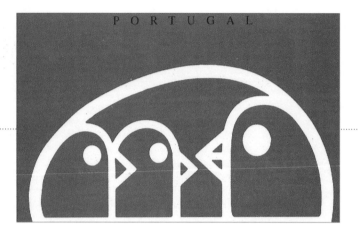

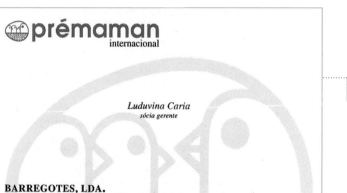

DESIGN FIRM MA&A—Mário Aurélio & Asscociados

ART DIRECTOR Mário Aurélio

DESIGNERS Mário Aurélio, Rosa Maia

CLIENT Prémaman

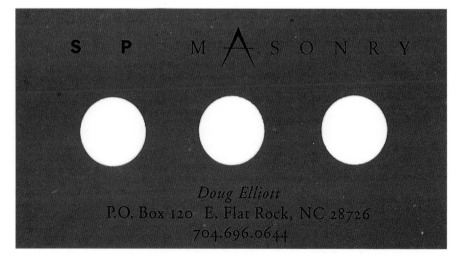

DESIGN FIRM Tower of Babel

DESIGNER Eric Stevens

CLIENT SP Masonry

TOOLS Macromedia FreeHand

PAPER/PRINTING Confetti Rust/Groves Printing

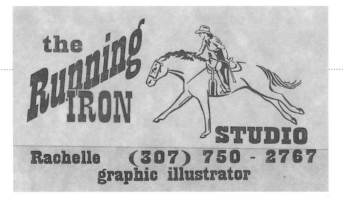

DESIGN FIRM The Running Iron Studio

ALL DESIGN Rachelle Kolby

CLIENT The Running Iron Studio

TOOLS Pen and ink

PAPER/PRINTING Astroparche Ancient
Gold 65 lb./Offset printing

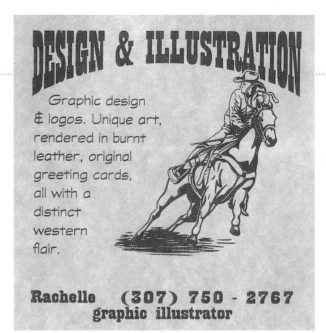

DESIGN FIRM MA&A—Mário Aurélio Associados

ART DIRECTOR Mario Aurélio

DESIGNERS Mario Aurélio, Rosa Maia

CLIENT DecoPaço

DESIGN FIRM Charney Design

ART DIRECTOR/DESIGNER Carol Inez Charney

CLIENT Darla Parr, D.C.

TOOLS QuarkXPress, Adobe Photoshop

PAPER/PRINTING Starwhite Vicksburg/Offset

JAN MUCKLESTONE

COSMOPOLITAN
GRILL

320 THIRD STREET

SAN FRANCISCO

CALIFORNIA

94107 · USA

PHONE
415.546.3131

DESIGN FIRM Tharp Did It
ART DIRECTOR Rick Tharp
DESIGNERS Rick Tharp, Susan Craft
CLIENT Cosmopolitan Grill
TOOLS Ink, Macintosh
PAPER/PRINTING Simpson Paper
Company/Simon Printing

DESIGN FIRM MA&A—Mário Aurélio & Associados
ART DIRECTOR Mário Aurélio
DESIGNERS Mário Aurélio, Rosa Maia
CLIENT Cozingas/Tors

DESIGN FIRM After Hours Creative
ART DIRECTOR/DESIGNER After Hours Creative
CLIENT ENX

DESIGN FIRM
Di Luzio Diseño
ART DIRECTOR/DESIGNER
Hector Di Luzio
CLIENT
Venus Hotel
PAPER/PRINTING
Offset

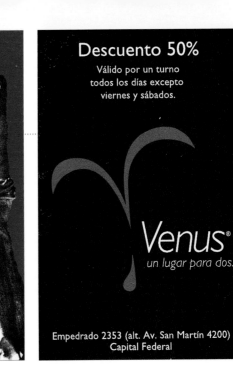

DESIGN FIRM
Rick Eiber Design (RED)
ART DIRECTOR/DESIGN
Rick Eiber
CLIENT
Ron Rabin
TOOLS
Debossed with actual
photo print, each card in Gl. Env.
PAPER/PRINTING
Teton/Engraved

DESIGN FIRM
Steve Trapero Design
ART DIRECTOR/DESIGNER
Steve Trapero
CLIENT
Cal Pack
TOOLS
Adobe PageMaker, Adobe Illustrator
PAPER/PRINTING
House uncoated/Black ink

SYMMETRY PRODUCTIONS

Sara Gray
Principal

DESIGN FIRM Corridor Design

ALL DESIGN Ejaz Saifullah

CLIENT Stout's Lodge

TOOLS Adobe Photoshop,
Adobe Illustrator, QuarkXPress

PAPER/PRINTING French Speckletone,
Oatmeal/Rooney Printing Co.

DESIGN FIRM
Stowe Design

ART DIRECTOR/DESIGNER
Jodie Stowe

CLIENT
Symmetry Productions

PAPER/PRINTING
Aztec Printing

DEB BOWDEN
Human Resource Project Manager

P.O. Box 231
Paterson, WA 99345
509-875-4204
Fax 509-875-2568

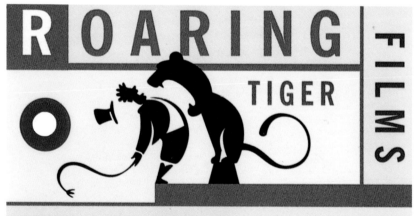

266 WEST BLITHEDALE. MILL VALLEY. CA. 94941

DESIGN FIRM Hornall Anderson
Design Works, Inc.

ART DIRECTOR John Hornall

DESIGNERS John Hornall,
Debra Hampton, Mary Chin Hutchinson

ILLUSTRATOR Jerry Nelson

CLIENT Columbia Crest Winery

TOOLS QuarkXPress

PAPER/PRINTING Neenah Environment
Recycled, Desert Storm, Wove, Woodstock Wove

DESIGN FIRM Dogstar
ART DIRECTOR/DESIGNER Jennifer Martin
ILLUSTRATOR Rodney Davidson
CLIENT Roaring Tiger Films
TOOLS Adobe Photoshop, Macromedia FreeHand, QuarkXPress

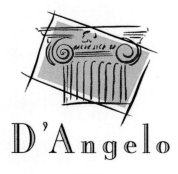

D'Angelo

Construction Ltd.

Franco D'Angelo

34628 Ascott Avenue
Abbotsford, B.C. V2S 4V9
Telephone (604) 556-3727
Facsimile (604) 556-3728

DESIGN FIRM Blue Suede Studios
ALL DESIGN Justin Baker
CLIENT D'Angelo Construction
PAPER/PRINTING Classic Laid/Ultratech Printers

COPYWRITING REPORTING

EDITING SALES PROMOTION

DOUGLAS C. SHIBUT
6210 ELLIS AVENUE | RICHMOND, VA | 23228
804 | 264 | 1168

DESIGN FIRM The Home Studio
ART DIRECTOR/DESIGNER C. Benjamin Dacus
CLIENT Douglas C. Shibut
TOOLS QuarkXPress, Adobe Photoshop, Adobe Illustrator
PAPER/PRINTING Classic Crest/Offset

DENNIS
HAYES
&
associates
incorporated

305 East 46 Street New York NY 10017-3058
telephone 212 980 0300 fax 212 755 1737

DESIGN FIRM Sagmeister, Inc.
ART DIRECTOR Stefan Sagmeister
DESIGNERS Stefan Sagmeister, Eric Zim
ILLUSTRATOR Eric Zim
CLIENT Dennis Hayes
PAPER/PRINTING Strathmore Writing 25% cotton

Robert F. Hernandez
Investigator
Post Office Box 9910
San Diego, CA 92109
Phone 619 488-4044

DESIGN FIRM Mires Design
ART DIRECTOR/DESIGNER José Serrano
ILLUSTRATOR Tracy Sabin
CLIENT Midland Research
PAPER/PRINTING Speckletone

Robert H. Whiteside

President / Designer

1533 E. Avenue J-3

Lancaster, CA 93535

Phone 805 • 940 • 5953

Modem 805 • 945 • 2291

DESIGN FIRM Steve Trapero Design
ART DIRECTOR/DESIGNER Steve Trapero
CLIENT Whiteside Design Studio
TOOLS Adobe PageMaker, Adobe Illustrator
PAPER/PRINTING House uncoated/Black ink

Matthew **Davies**

Graphic **Designer**
Tel 0161 980 3210

WA15 7TQ

Graphic **Designer**
Tel 0161 980 3210

ART DIRECTOR/DESIGNER
Matthew Davies
TOOLS
Adobe Illustrator, QuarkXPress
PAPER/PRINTING
300 gsm/Silk lithography

DESIGN FIRM Stefan Dziallas Design
DESIGNER/ILLUSTRATOR Stefan Dziallas
CLIENT Stefan Dziallas
TOOLS Photoshop, Quark, Macintosh
PAPER/PRINTING 300 g Matt, Schneidersöhne

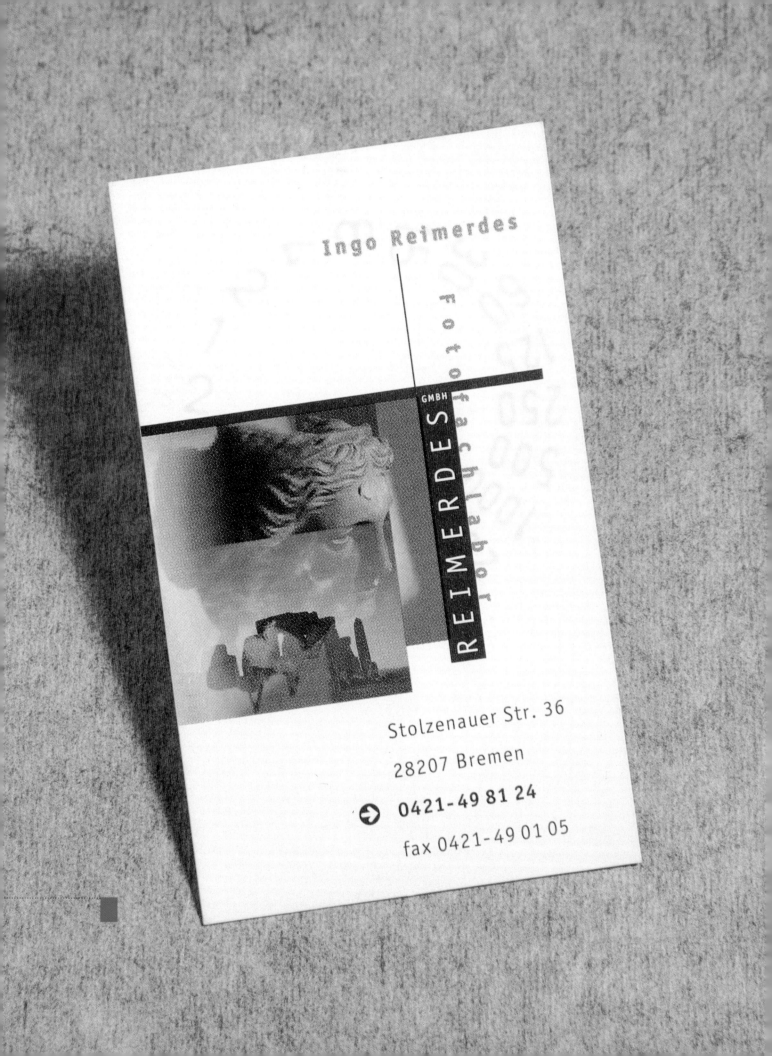

Ingo Reimerdes

GMBH

REIMERDES Fotofachlabor Foto

Stolzenauer Str. 36

28207 Bremen

0421- 49 81 24

fax 0421- 49 01 05

Joel Morgenstern

444 Columbus Avenue
San Francisco, CA 94133

Tel: 415.433.9111

Fax: 415.362.6292

Email: HotelBoheme@
MCIMail.com

DESIGN FIRM Aerial
ART DIRECTOR/DESIGNER Tracy Moon
ILLUSTRATOR John Mattos (logotype)
PHOTOGRAPHERS Jerry Stoll, R. J. Muna
CLIENT Hotel Bohème
TOOLS Adobe Photoshop, QuarkXPress

Peter Comitini *principal*

Peter Comitini: Design
611 Broadway
Suite 206
New York, NY 10012
212.228.2727
Fax 212.260.9058
comitini@mindspring.com

Peter Comitini *principal*

Peter Comitini: Design
611 Broadway
Suite 206
New York, NY 10012
212.228.2727
Fax 212.260.9058
comitini@mindspring.com

Peter Comitini *principal*

Peter Comitini: Design
611 Broadway
Suite 206
New York, NY 10012
212.228.2727
Fax 212.260.9058
comitini@mindspring.com

DESIGN FIRM Peter Comitini Design
ART DIRECTOR/DESIGNER Peter Comitini
TOOLS Adobe Illustrator, QuarkXPress, Power PC
PAPER/PRINTING Neenah UV Ultra

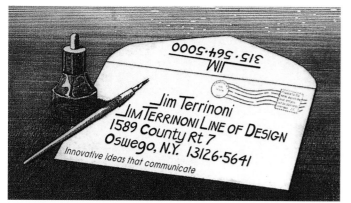

DESIGN FIRM Jim Terrinoni Line of Design
ART DIRECTOR Jim Terrioni
TOOLS Freehand artwork, Adobe Photoshop,
QuarkXPress, Adobe Illustrator
PAPER/PRINTING 80 lb. cover

RACEFEST FORTWORTH

RaceFest Fort Worth, Inc.
777 Taylor Street, Suite 1080
Fort Worth, Texas 76102
817.335.RACE (7223)
FAX 817.335.2626
RaceFest@downiepro.com

Gary Cumbie
Steering Committee
Chairman

DESIGN FIRM Witherspoon Advertising
ALL DESIGN Rishi Seth
TOOLS Adobe Illustrator
CLIENT RaceFest Fort Worth
PAPER/PRINTING Starwhite Vicksburg Tiara High-Tech Finish Cover Plus

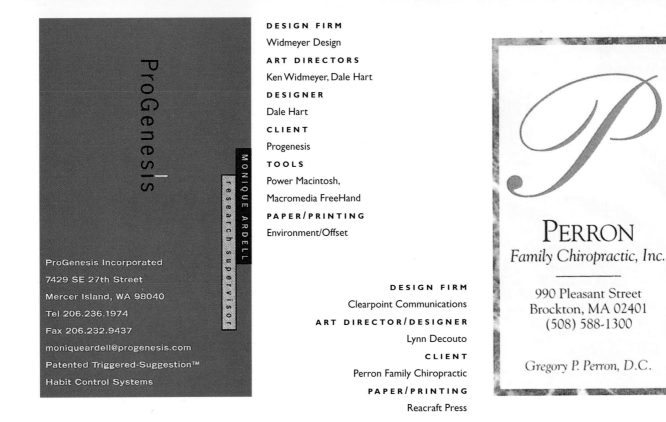

DESIGN FIRM
Widmeyer Design
ART DIRECTORS
Ken Widmeyer, Dale Hart
DESIGNER
Dale Hart
CLIENT
Progenesis
TOOLS
Power Macintosh,
Macromedia FreeHand
PAPER/PRINTING
Environment/Offset

DESIGN FIRM
Clearpoint Communications
ART DIRECTOR/DESIGNER
Lynn Decouto
CLIENT
Perron Family Chiropractic
PAPER/PRINTING
Reacraft Press

DESIGN FIRM Insight Design Communications
ALL DESIGN Sherrie Holdeman, Tracy Holdeman
CLIENT Jitters
TOOLS Power Macintosh 7500, Macromedia
FreeHand, Adobe Photoshop
PAPER/PRINTING French Speckletone Oatmeal
70 lb. text, Classic Crest Solar White 80 lb. cover

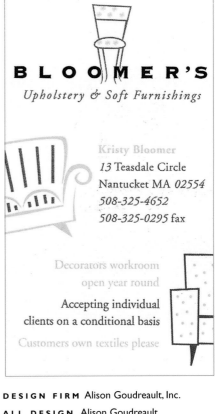

DESIGN FIRM Alison Goudreault, Inc.
ALL DESIGN Alison Goudreault
CLIENT Bloomer's Upholstery
TOOLS Adobe Illustrator
PAPER/PRINTING Strathmore Ultimate
White/Copy Cop

COONARA PRIVATE HOSPITAL

LORETO DAVEY CEO

6TH FLOOR
ALFRED HOSPITAL
COMMERCIAL ROAD
PRAHAN VICTORIA 3181
PHONE (03) 9520 9200
FAX (03) 9521 2775

A meeting place for quality health care

DESIGN FIRM
Watts Graphic Design
ART DIRECTORS/
DESIGNERS
Helen Watts, Peter Watts
CLIENT
Coonara Private Hospital
TOOLS
Macintosh
PAPER/PRINTING
Two color

The Knowledge Navigators

GLENN McIVER
DIRECTOR

GLENGROVE
CHASES LANE PIPERS CREEK
3444 VICTORIA
PHONE 0418 584 057
FAX (054) 22 1447

A DIVISION OF MONSOON TRADING
(AUSTRALIA) PTY. LTD.

DESIGN FIRM Watts Graphic Design
ART DIRECTORS/DESIGNERS Helen Watts,
Peter Watts
CLIENT The Knowledge Navigators
TOOLS Macintosh
PAPER/PRINTING Teton/one color

Virtual Garden

Shirley Read-Jahn
communications manager

221 Main Street
Suite 480
San Francisco, CA 94105
P 415.908.4967
F 415.908.2010
E readjahns@tpv.com

http://vg.com

DESIGN FIRM Tharp Did It
ART DIRECTOR Rick Tharp
DESIGNERS Rick Tharp, Nicole Coleman
ILLUSTRATOR Rick Olson
CLIENT Time Warner
TOOLS Ink, Macintosh

t 310 204 1995 f 310 204 4879

Stan Evenson
principal

4445 overland avenue
culver city california 90230
evensoninc@aol.com

edg

evenson design group

DESIGN FIRM Evenson Design Group
ART DIRECTOR Stan Evenson
DESIGNER Amy Hershman
PAPER/PRINTING Anderson Printing

Annex

Leslie Vasquez

...nnex

...prises
...ue, Santa Cruz CA 95062
...4-6456 Fax 408/477-0289

DESIGN FIRM Charney Design
ALL DESIGN Carol Inez Charney
CLIENT Annex Enterprises
TOOLS QuarkXPress, Adobe Photoshop
PAPER/PRINTING Vintage/Offset

lumiforma
iluminação, lda

telemóvel 0931 57 97 69
- tel/fax +351.2.454 20 63
rua das valas de cima 49, jovim
4420 gondomar
portugal

DESIGN FIRM
MA&A—Mário Aurélio & Associados
ART DIRECTOR Mário Aurélio
DESIGNERS Mário Aurélio, Rosa Maia
CLIENT Lumiforma/Iluminage, LDA

lumiforma

DESIGN FIRM Sivustudio
ART DIRECTOR Jaana Aartomaa
CLIENT Pirjo Lindstrom
TOOLS Macromedia FreeHand, Macintosh
PAPER/PRINTING Offset

Pirjo Lindström

Lastenkodinkatu 2-10 R 6
00180 Helsinki
Puh. (09) 694 9969
(Tel. +358 9 694 9969)

ALIYA S. KHAN
graphic design & consulting
864.627.9065
aliya@viperlink.com
812 Gloucester Ferry Road
Greenville, SC 29607

DESIGN FIRM One, Graphic Design & Consulting
ART DIRECTOR/DESIGNER Aliya S. Khan
CLIENT One, Graphic Design & Consulting
TOOLS CorelDraw, PC
PAPER/PRINTING Neenah Paper
Classic Crest New Sawgrass

DESIGN FIRM Tharp Did It
ART DIRECTOR Rick Tharp
DESIGNERS
Rick Tharp, Amy Bednarek, Susan Craft
CLIENT Ladbrokes/London
TOOLS Macintosh
PAPER/PRINTING
Simpson Starwhite Vicksburg/Simon Printing

DESIGN FIRM Tower of Babel
DESIGNER Eric Stevens
CLIENT Tower of Babel
TOOLS Macromedia FreeHand
PAPER/PRINTING Groves Printing

DESIGN FIRM
Melinda Thede
ART DIRECTOR
Lorelle Thomas
DESIGNER
Melinda Thede
CLIENT
Melinda Thede
TOOLS
Adobe Illustrator
PAPER/PRINTING
Transparency film/handmade

Carlos Barros
gerente

Bizance · Pedro Miguel & Irmãos, Lda

R. Quinta de Santa Maria, 119

Maximinos

4700 Braga

Telefone:(053)691 486

Fax:(053)691 486

DESIGN FIRM MA&A—Mário Aurélio & Associados
ART DIRECTOR Mário Aurélio
DESIGNERS Mário Aurélio, Rosa Maia
CLIENT Bizance Interiors

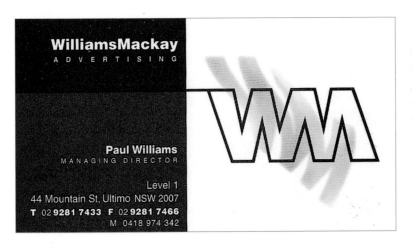

DESIGN FIRM
Lucy Walker Graphic Design
ART DIRECTOR/DESIGNER Lucy Walker
CLIENT Williams MacKay Advertising
TOOLS Adobe Illustrator
PAPER/PRINTING Coated artboard

DESIGN FIRM Charney Design
ALL DESIGN Carol Inez Charney
CLIENT Heinz Communications
TOOLS Adobe Illustrator
PAPER/PRINTING Environment
Duplex/Offset

HEINZ COMMUNICATIONS
ZIGI Z. HEINZ

VIDEO PRODUCTION

6950 HIGHWAY 9
FELTON, CA 95018
PHONE 408/335-3456
FAX 408/335-0722
PAGER 408/989-7777

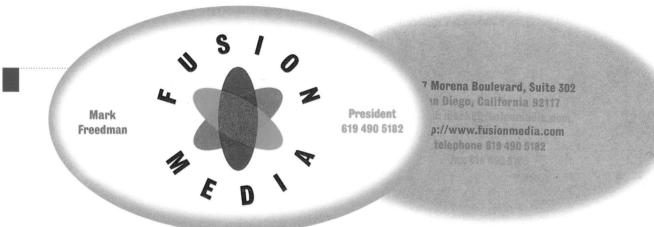

FUSION MEDIA

Mark
Freedman

President
619 490 5182

7 Morena Boulevard, Suite 302
n Diego, California 92117
E mark@fusionmedia.com
p://www.fusionmedia.com
telephone 619 490 5182

DESIGN FIRM Mires Design
ART DIRECTOR John Ball
DESIGNERS John Ball, Deborah Horn
CLIENT Fusion Media
PAPER/PRINTING Starwhite

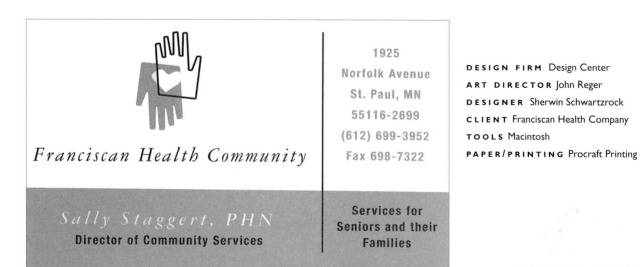

1925
Norfolk Avenue
St. Paul, MN
55116-2699
(612) 699-3952
Fax 698-7322

Franciscan Health Community

Sally Staggert, PHN
Director of Community Services

Services for
Seniors and their
Families

DESIGN FIRM Design Center
ART DIRECTOR John Reger
DESIGNER Sherwin Schwartzrock
CLIENT Franciscan Health Company
TOOLS Macintosh
PAPER/PRINTING Procraft Printing

DESIGN FIRM Prestige Design
ALL DESIGN Sarah Harris
CLIENT Prestige Design
TOOLS Adobe Illustrator,
Adobe Photoshop, QuarkXPress
PAPER/PRINTING Classic Columns
Marigold/Black foil embossed

PRESTIGE
DESIGN

SARAH HARRIS

602 JOHNS DRIVE
EULESS, TX 76039
METRO 817.540.1560
FAX 817.540.1680
VM/PAGER 817.858.1510

SPECIALIZING IN THE
COMPLETE PRODUCTION
OF DISTINCTIVE
MARKETING MATERIALS

COPY

PHOTOGRAPHY

DESIGN

PRINTING

Alexandre Vignoli

Graphic Designer

p.o.box 2428 southampton, ny 11969
phone/fax (516) 287-2978
vignolij9@aol.com

DESIGN FIRM Alexandre Vignoli
ALL DESIGN Alexandre Vignoli
CLIENT Alexandre Vignoli
TOOLS Bryce, Adobe Illustrator, QuarkXPress
PAPER/PRINTING Paper direct (almond cream)/Color laser printer

DESIGN FIRM Cross Colors
ART DIRECTORS Joanina Swart, Janine Rech
DESIGNER Joanina Swart
ILLUSTRATORS Janine Rech, Mark Day, Peter Simpson
CLIENT Cross Colours
TOOLS Macintosh, Macromedia FreeHand, paint, scaper board
PAPER/PRINTING Five-color litho

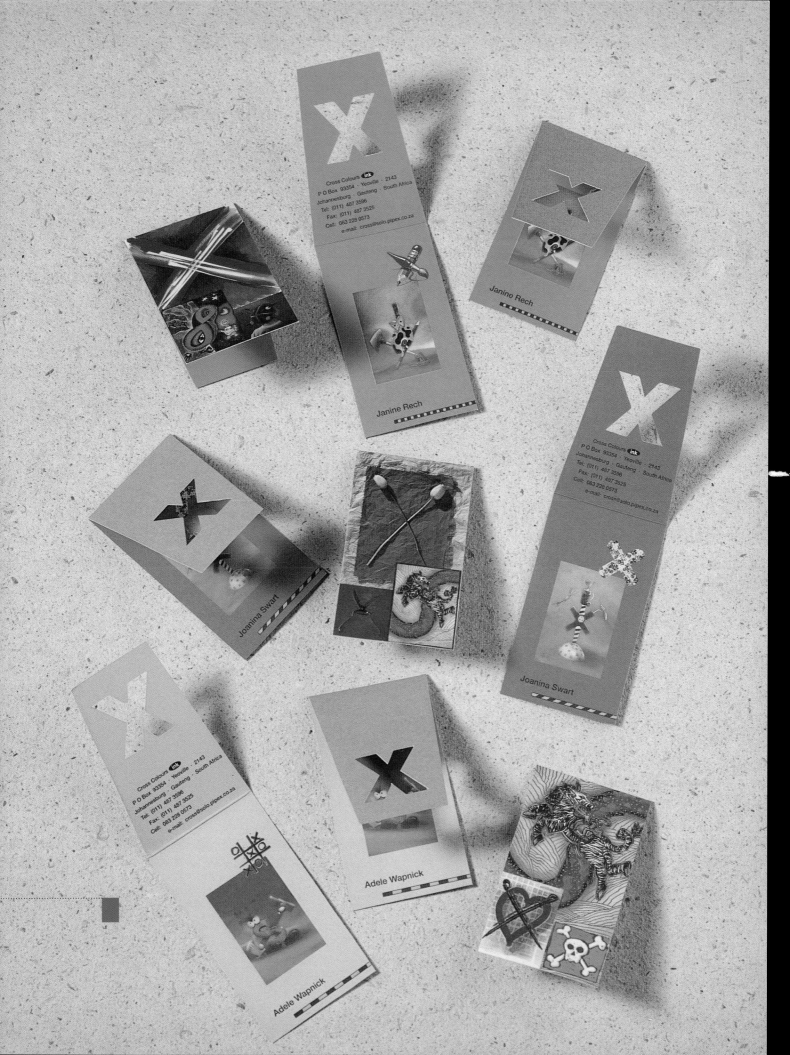

Lee Rodgers
PRINCIPAL, RETAIL SALES

1490 Frontage Road
O'Fallon, IL 62269
618 224-9133 *Phone*
618 224-9059 *Fax*

DESIGN FIRM Phoenix Creative, St. Louis
ART DIRECTOR/DESIGNER
Ed Mantels-Seeker
ILLUSTRATORS Ed Mantels-Seeker, Ann Guillot
TOOLS Macromedia FreeHand
PAPER/PRINTING Four-color offset

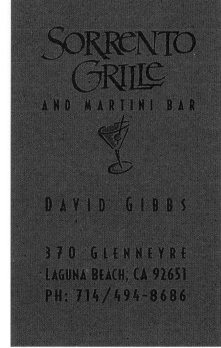

DESIGN FIRM On The Edge
ART DIRECTOR Jeff Gasper
DESIGNER Gina Mims
CLIENT Sorrento Grille
TOOLS Adobe Illustrator,
QuarkXPress, Adobe Photoshop
PAPER/PRINTING Quest brown

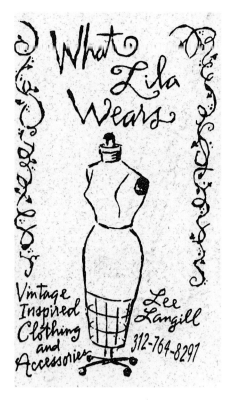

DESIGN FIRM Jim Lange Design
ALL DESIGN Jim Lange
CLIENT Lee Langill
TOOLS Pen and ink

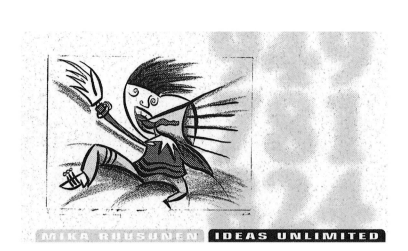

DESIGN FIRM M-DSIGN
ALL DESIGN Mika Ruusunen
CLIENT M-DSIGN
TOOLS Macintosh
PAPER/PRINTING Offset

Ida Linnet

REKLAMEAFDELINGEN

LØVENS KEMISKE FABRIK

Industriparken 55

2750 Ballerup

Telefon 44 94 58 88

Direkte 44 92 36 66 ----> 2563

Privat 44 68 05 40

Fax 44 92 35 95

DESIGN FIRM
Department 058
ART DIRECTOR/DESIGNER
Vibeke Nødskov
CLIENT
Løvens Kemiske Fabrik
TOOLS
Adobe Illustrator, QuarkXPress
PAPER/PRINTING
Green cardboard/One color

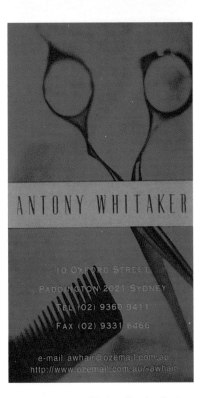

DESIGN FIRM Mother Graphic Design
ART DIRECTOR/DESIGNER Kristin Thieme
PHOTOGRAPHER Petrina Tinslay
CLIENT Antony Whitaker Hairdressing

Kimberly Bykerk, ASID

ASSOCIATE

THE RETAIL GROUP

2025 FIRST AVENUE, SUITE 470

SEATTLE, WASHINGTON 98121

FACSIMILE 206.441.8710

TELEPHONE 206.441.8330

DESIGN FIRM Widmeyer Design
ART DIRECTORS Ken Widmeyer, Dale Hart
DESIGNER/ILLUSTRATOR Dale Hart
CLIENT The Retail Group
TOOLS Power Macintosh, Adobe Photoshop,
Macromedia FreeHand
PAPER/PRINTING Environment/Offset

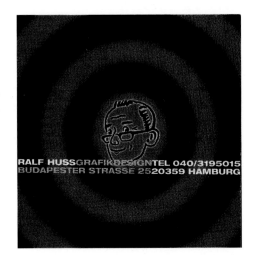

ART DIRECTOR/ILLUSTRATOR Ralf Huss
TOOLS Macintosh, Adobe Photoshop, QuarkXPress

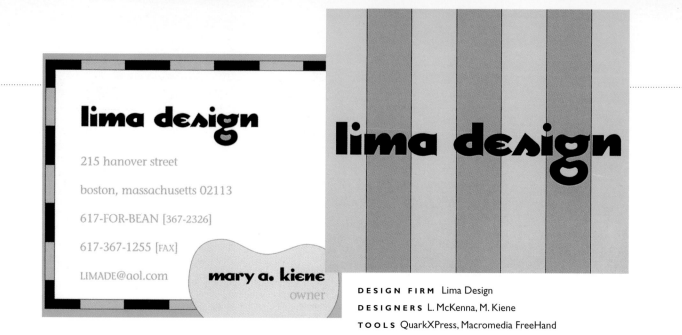

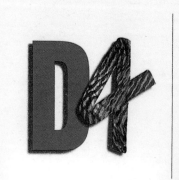

lima design

215 hanover street

boston, massachusetts 02113

617-FOR-BEAN [367-2326]

617-367-1255 [FAX]

LIMADE@aol.com

mary a. kiene
owner

DESIGN FIRM Lima Design
DESIGNERS L. McKenna, M. Kiene
TOOLS QuarkXPress, Macromedia FreeHand
PAPER/PRINTING Potlatch Paper

TV | RADIO | PRINT | WEB

Kurt Shore
A Helluva Nice Guy

4100 Main Street, Suite 210
Philadelphia, PA 19127-1623
215.483.4555 fax 215.483.4554
http://www.d4tv.com

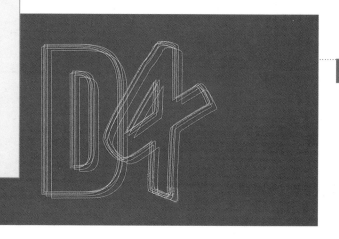

DESIGN FIRM D4 Creative Group
ALL DESIGN Wicky Lee
CLIENT D4 Creative Group
TOOLS Adobe Photoshop, Adobe Illustrator, QuarkXPress
PAPER/PRINTING Strathmore Writing/Five
colors over one color

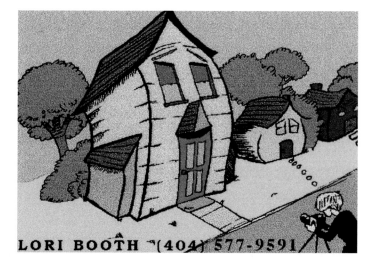

LORI BOOTH (404) 577-9591

DESIGN FIRM Bumbershoot, CSC
ILLUSTRATOR Chris Thorne
CLIENT Lori Booth, Architectural Photography
TOOLS Pen and Ink, Adobe Photoshop
PAPER/PRINTING Watercolor paper/Ink jet

NAME
BARRY LAWSON
CHIEF FINANCIAL OFFICER

ADDRESS
5497 170TH PLACE SE
BELLEVUE, WA 98006

PHONE
VOICE 206.649.0346
FAX 206.649.0122

TICKETING

TOURS & CRUISES

PASSPORT & CURRENCY SERVICES

TRAVEL BOOKS, GUIDES & VIDEOS

LUGGAGE & ACCESSORIES

BON VOYAGE BASKETS

ON-LINE INFORMATION

GIFT CERTIFICATES

DESIGN FIRM Rick Eiber Design (RED)
ALL DESIGN Rick Eiber
CLIENT Today's Traveler
PAPER/PRINTING Three-colors,
over two-colors offset

KIMBERLY
EBBERS WASS

5012 E.P. TRUE PARKWAY • WEST DES MOINES, IA 50265
(515) 221-0821 • FAX (515) 221-9890

833 42ND STREET • DES MOINES, IA 50312
(515) 255-8998 • FAX (515) 255-9040

233 MAIN STREET • AMES, IA 50010
(515) 232-1580 • FAX (515) 232-1580

DESIGN FIRM Sayles Graphic Design
ALL DESIGN John Sayles
CLIENT Alphabet Soup
PAPER/PRINTING Neenah Environment
white wove, double cover/Offset

Planet Comics

Smith Haven Mall, Space E-15

Middle Country Road

Lake Grove, New York 11755

516-724-4096

John A. Gagliardi, CEO

DESIGN FIRM Kiku Obata & Company
ART DIRECTOR/DESIGNER Rich Nelson
CLIENT Planet Comics

DESIGN FIRM LSL Industries

DESIGNERS Elisabeth Spitalny, Franz M. Lee

CLIENT LSL Industries

TOOLS QuarkXPress, Adobe Photoshop, Adobe Illustrator

PAPER/PRINTING French Construction Factory Green

DESIGN FIRM Corcoran Communications

ART DIRECTOR Tom Corcoran

DESIGNER/ILLUSTRATOR Michael Bentley

CLIENT Scholarship Surety, Inc.

TOOLS Pencil and paper, Adobe Illustrator, QuarkXPress

PAPER/PRINTING Tiara Vicksburg Text #100/Tru-Art Color Graphics

Ralph Struchtemeyer
PRESIDENT

901 Missouri Blvd., #221 • Jefferson City, MO 65109
Phone: 1-800-472-4652 • FAX: (573) 896-8251
E-Mail: sshiprt@computerland.net

Universität Kaiserslautern

Prof. Dr. Friedhelm Bliemel Postfach 3049
 67653 Kaiserslautern
 Tel 06 31/205-40 40
 Fax 06 31/205-33 92

DESIGN FIRM Geffert Design

DESIGNER Gerald Geffert

CLIENT Universität Kaiserslautern

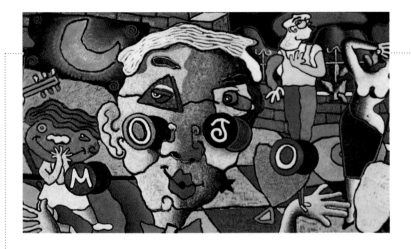

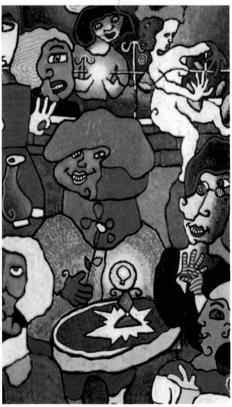

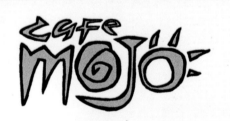

94 Massachusetts Ave • Boston MA. 02118
Phone 617.247.9922 • Fax 617.247.7955

DESIGN FIRM On The Edge
ART DIRECTOR Jeff Gasper
DESIGNER Gina Mims
ILLUSTRATOR Wok
CLIENT Cafe Mojo
TOOLS Adobe Illustrator,
QuarkXPress, Adobe Photoshop
PAPER/PRINTING Luna White Cover

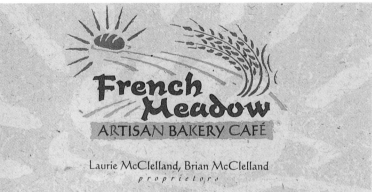

DESIGN FIRM Duck Soup Graphics

ART DIRECTOR/DESIGNER William Doucette

CLIENT French Meadow Bakery

TOOLS Macromedia FreeHand, QuarkXPress

PAPER/PRINTING Classic Laid/Three match colors

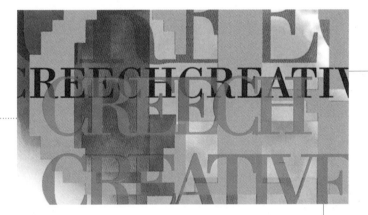

CREECHCREATIVE

6319 FAIRHURST AVENUE
CINCINNATI, OHIO
45213
513/351-3818
FACSIMILE: 513/631-6938

TIMOTHY J. CREECH

DESIGN FIRM Creech Creative

ALL DESIGN Tim Creech

CLIENT Creech Creative

TOOLS Adobe Photoshop, Adobe Illustrator

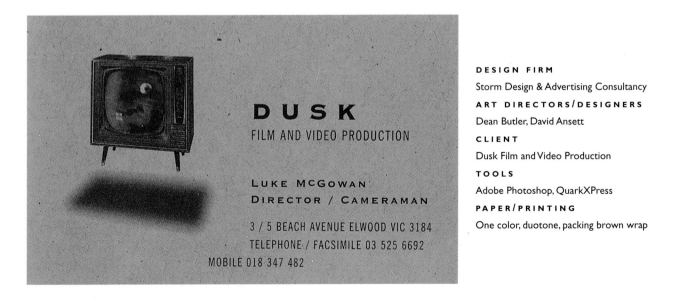

DESIGN FIRM
Storm Design & Advertising Consultancy

ART DIRECTORS/DESIGNERS
Dean Butler, David Ansett

CLIENT
Dusk Film and Video Production

TOOLS
Adobe Photoshop, QuarkXPress

PAPER/PRINTING
One color, duotone, packing brown wrap

An Eat Well Production

DESIGN FIRM Flaherty Art & Design
ALL DESIGN Marie Flaherty
CLIENT Fireking Baking Company of Eat Well, Inc.
TOOLS Adobe Illustrator

Patty Kane
owner

15 North Street • Hingham • MA • 02043
617-740-9400 • Fax 617-740-0440

An Eat Well Production

Todd Burgard Design
342 Walnut Street
Columbia, PA 17512
717·684·5896
gideon@redrose.net

Burgard Design
342 Walnut Street
Columbia, PA 17512
717·684·5896
gideon@redrose.net

DESIGN FIRM Burgard Design
ART DIRECTOR/DESIGNER Todd Burgard
CLIENT Burgard Design
TOOLS Hand-perfed using antique wheel punch
PAPER/PRINTING Neenah classic laid mahogany, camel hair duplex/
Letterpress with linotype typesetting, two color over one

DESIGN FIRM Solo Grafica
ART DIRECTOR/DESIGNER Yelena Suleyman
CLIENT Extrema Software International
TOOLS Macintosh
PAPER/PRINTING Neenah, Two color

Michael Bogart,

dr Michael Bogart, M.D., F.R.C.P. (C)

366 ADELAIDE STREET EAST SUITE 345 TORONTO

ONTARIO M5A 3X9 TELEPHONE (416) 361 6182

DESIGN FIRM Teikna
ART DIRECTOR/DESIGNER Claudia Neri
CLIENT Michael Bogart
TOOLS QuarkXPress
PAPER/PRINTING Graphika/Two color

chris st. cyr

graphic design

ph. no. 617.625.7265

fax no. 617.625.9388

chrissc@usal.com

4 electric ave. #2

somerville,

ma 02144

chris st. cyr

graphic design

ph. no. 617.625.7265

fax no. 617.625.9388

chrissc@usal.com

4 electric ave. #2

somerville,

ma 02144

chris st. cyr

graphic design

ph. no. 617.625.7265

fax no. 617.625.9388

chrissc@usal.com

4 electric ave. #2

somerville,

ma 02144

DESIGN FIRM Chris St. Cyr Graphic Design
ART DIRECTOR/DESIGNER Chris St. Cyr
CLIENT Chris St. Cyr Graphic Design
TOOLS QuarkXPress, Adobe Illustrator,
rubber stamp

DESIGN FIRM Widmeyer Design
ART DIRECTORS Ken Widmeyer, Dale Hart
DESIGNER/ILLUSTRATOR Dale Hart
CLIENT Rolling Cones
TOOLS Power Macintosh, Adobe Photoshop,
Macromedia FreeHand
PAPER/PRINTING Mead paper/Offset

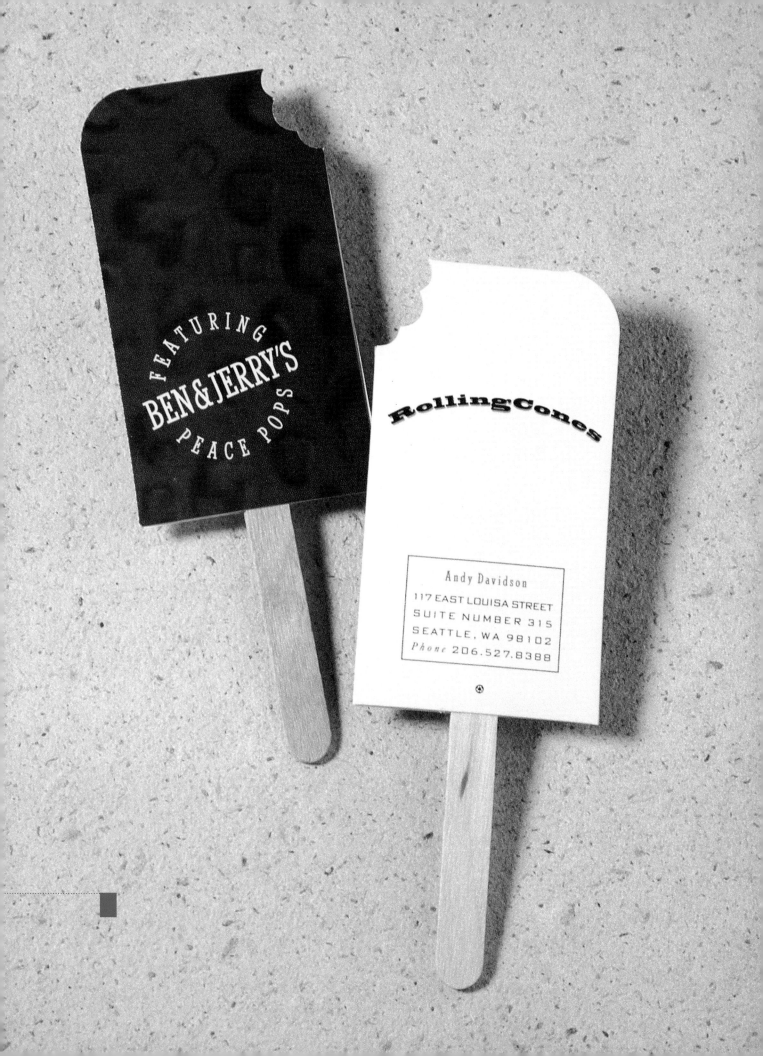

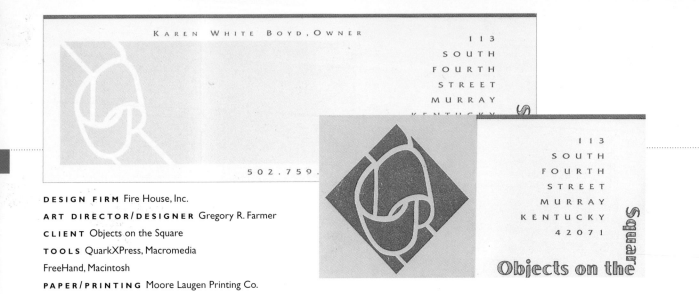

KAREN WHITE BOYD, OWNER

113
SOUTH
FOURTH
STREET
MURRAY
KENTUCKY

502.759.

113
SOUTH
FOURTH
STREET
MURRAY
KENTUCKY
42071

Objects on the Square

DESIGN FIRM Fire House, Inc.
ART DIRECTOR/DESIGNER Gregory R. Farmer
CLIENT Objects on the Square
TOOLS QuarkXPress, Macromedia
FreeHand, Macintosh
PAPER/PRINTING Moore Laugen Printing Co.

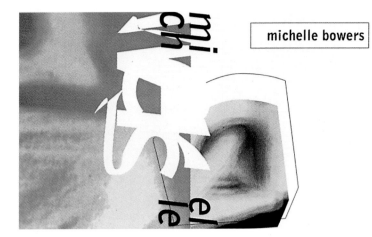

michelle bowers

DESIGN FIRM Michelle Bowers
TOOLS Adobe Photoshop,
Macromedia FreeHand

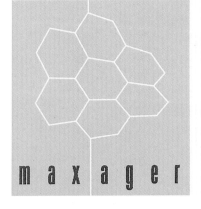

Michael Rothschild
President & CEO

maxager technology inc.
2173 east francisco blvd
san rafael, california 94901
t 415.454.1000
f 415.454.7460
mrothschild@maxager.com

DESIGN FIRM Aerial
ART DIRECTOR Tracy Moon
DESIGNERS Tracy Moon, Amy Gustincic
CLIENT Maxager Technology, Inc.
TOOLS Adobe Illustrator, QuarkXPress

DESIGN FIRM Büro B.
DESIGNER Daniel Bastian
CLIENT Gruppe Z
TOOLS QuarkXPress
PAPER/PRINTING Karten Karton/Offset

Markus Zietlow
Geschäftsführer
Medienatelier Alexanderstraße 9b
D-28203 Bremen
Telefon 0421 70 76 76
Telefax 0421 70 06 17
Internet 100613.2750 @ compuserve.com

gruppe ||| Z

Calypso
IMAGING

SCOTT BATDORFF
PRINT DEPARTMENT MANAGER

CALYPSO IMAGING, INC.
2000 MARTIN AVENUE
SANTA CLARA, CALIFORNIA
ZIP 95050.2700

TEL 408.727.2318
TOLL FREE 800.794.2755
FAX 408.727.1705

IMAGES/EVERYTHING sm

DESIGN FIRM Aerial
ART DIRECTOR/DESIGNER Tracy Moon
CLIENT Calypso
TOOLS Adobe Illustrator, QuarkXPress
PAPER/PRINTING Craftsmen Printers

DESIGN FIRM Keiler Design Group
ART DIRECTOR Mike Scricco
DESIGNERS Liz Dzilenski, Glen DeCicco
CLIENT Keiler & Company
TOOLS QuarkXPress
PAPER/PRINTING Mohawk Superfine

Keiler & Company

304 Main Street
Farmington, CT 06032

Michael Scricco
Director
The Design Group

CONCEPTONTWIKKELING • VORMGEVING • UITVOERING

LAURÍA GRAFISCH ONTWERP

Martha Lauría

Jacob van Heemskerklaan 15
3603 GH Maarssen

tel. 0346 571560
fax 0346 551268

E-mail: lauria@xs4all.nl

DESIGN FIRM Lauría Grafisch Ontwerp
ALL DESIGN Martha Lauría
CLIENT Lauría Grafisch Ontwerp
TOOLS Acrylic paint, digital manipulation
PAPER/PRINTING Cordenons Officio/Two-color offset

http://www.xs4all.nl/~lauria/

NANCY YEASTING
DESIGN & ILLUSTRATION

3490 MONMOUTH AVENUE
VANCOUVER, B.C.
CANADA V5R 5R9

(604) 435-4965

DESIGN FIRM Nancy Yeasting
Design & Illustration
ALL DESIGN Nancy Yeasting
CLIENT Nancy Yeasting Design
& Illustration
TOOLS Hand drawn on marker pad,
QuarkXPress
PAPER/PRINTING Genesis
Milkweed/Two-color thermography

art & design

DHRUVI ACHARYA

8200 wisconsin ave suite 1607
bethesda md 20814 usa
tel : 3 0 1 . 6 5 2 . 4 5 8 5

DESIGN FIRM Dhruvi Art & Design
ALL DESIGN Dhruvi Acharya
CLIENT Druvi Art & Design
PAPER/PRINTING 80/100 lbs. card
stock/Screen

812 Gloucester Ferry Road, Greenville, SC 29607

company of 2

864.627.9065

Sabila Z. Husnain

DESIGN FIRM One, Graphic Design & Consulting
ART DIRECTOR/DESIGNER Aliya S. Khan
CLIENT Sabila Zakir Husnain
TOOLS CorelDraw, PC
PAPER/PRINTING Genesis Tallow

DESIGN FIRM Bartels & Company, Inc.
ART DIRECTOR David Bartels
DESIGNER/ILLUSTRATOR Aaron Segall
CLIENT Companion Baking Company
PAPER/PRINTING Mid West Printing

DESIGN FIRM
Fire House, Inc.
ART DIRECTOR/DESIGNER
Gregory R. Farmer
CLIENT
Twist Salon, Daphne Raider
TOOLS
QuarkXPress, Macromedia
FreeHand, Macintosh
PAPER/PRINTING
Schulze Printing

DESIGN FIRM Kanokwalee Design
ART DIRECTOR/DESIGNER Kanokwalee Pusitanun
CLIENT Kanokwalee Design
TOOLS Adobe Illustrator, QuarkXPress
PAPER/PRINTING Speckletone/Kraft

Marianne Worm
Executive Assistant

Ventana Europe a/s
Lyngsø Allé · DK - 2970 Hørsholm
+45-70 21 11 11 · direct +45-45 16 08 02
fax +45-70 21 11 12
Marianne.Worm@ventanaeurope.com
http://www.ventanaeurope.com

Ventana Europe

DESIGN FIRM Transparent Office
ART DIRECTOR/DESIGNER Vibeke Nødskov
CLIENT Ventana Europe
TOOLS Adobe Illustrator, QuarkXPress
PAPER/PRINTING Copper Cromalux/Two color

DESIGN FIRM Mother Graphic Design
ART DIRECTOR/DESIGNER Kristin Thieme
ILLUSTRATOR Melinda Dudley
CLIENT RA Records

DESIGN FIRM
Duck Soup Graphics
ART DIRECTOR/DESIGNER
William Doucette
CLIENT
Videotron
TOOLS
Adobe Illustrator, QuarkXPress
PAPER/PRINTING
Strathmore Elements/One match color,
foil embossed

DESIGN FIRM
Raven Madd Design
ART DIRECTOR/DESIGNER
Mark Curtis
CLIENT
Bowerman School

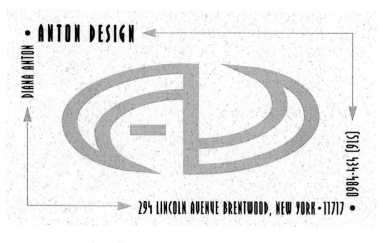

DESIGN FIRM Anton Design
ALL DESIGN Diana Anton
CLIENT Anton Design
TOOLS QuarkXPress, Adobe Illustrator

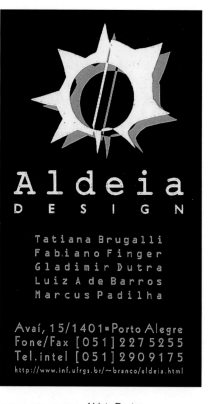

DESIGN FIRM Aldeia Design
ART DIRECTORS Marcus Padilha, Tatiana Brugalli
DESIGNERS Luis Barros, Fabiano Finger
ILLUSTRATOR Gladimir Dutra
CLIENT Aldeia Design
TOOLS CorelDraw
PAPER/PRINTING Couche 180 gsm/Silkscreen

Bischoff & Thiede

Fassaden & Bausanierung

Dualweg 10

28239 Bremen

Telefon / Telefax

(0421 64 49 018

DESIGN FIRM Charney Design
ART DIRECTOR/DESIGNER Carol
Inez Charney
PHOTOGRAPHER Carol Charney
CLIENT Jose McKanobb
TOOLS QuarkXPress, Adobe Photoshop
PAPER/PRINTING Vintage Velvet
Creme/Offset

DESIGN FIRM
Büro B.
DESIGNER/ILLUSTRATOR
Daniel Bastian
CLIENT
Bischoff & Thiede
TOOLS
QuarkXPress, Adobe Photoshop
PAPER/PRINTING
Karten Karton/Offset

Jose McKanobb

FITNESS COORDINATOR

CERTIFIED PERSONAL TRAINER

24 HOUR NAUTILUS

1261 SOQUEL AVENUE

SANTA CRUZ, CA 95062

408.454.0333

Fransbal
sociedade de representações de produtos e derivados metálicos, lda.

Francisco J. R. Barbosa
Direcção Comercial

Rua Gonçalo Cristóvão, 347 · sala 310 · 4000 Porto Portugal
Tel:(02)208 88 01 · Fax:(02)208 88 01

DESIGN FIRM MA&A—Mário Aurélio & Associados
ART DIRECTOR Mário Aurélio
DESIGNERS Mário Aurélio, Rosa Maia
CLIENT Fransbal

Acessórios para a indústria
e matéria-primas
Sociedade de representações
para metalo-mecânica
de produtos e derivados metálicos
Manutenção industrial
Acessórios para a indústria
e matéria-primas
para metalo-mecânica
Sociedade de representações
de produtos e derivados metálicos
Manutenção industrial

David M. Chandler
President

(319) 377-9245
(319) 377-9541 Fax
chandler @ iwork.net
http://www.iwork.net

5250 North Park Place NE
Suite 111
Cedar Rapids, IA 52402

DESIGN FIRM Marketing and Communications
Strategies, Inc.
ART DIRECTOR/DESIGNER Lloyd Keels
CLIENT Internet at Work
TOOLS Adobe Illustrator, QuarkXPress, Power
Macintosh 8100
PAPER/PRINTING Two color

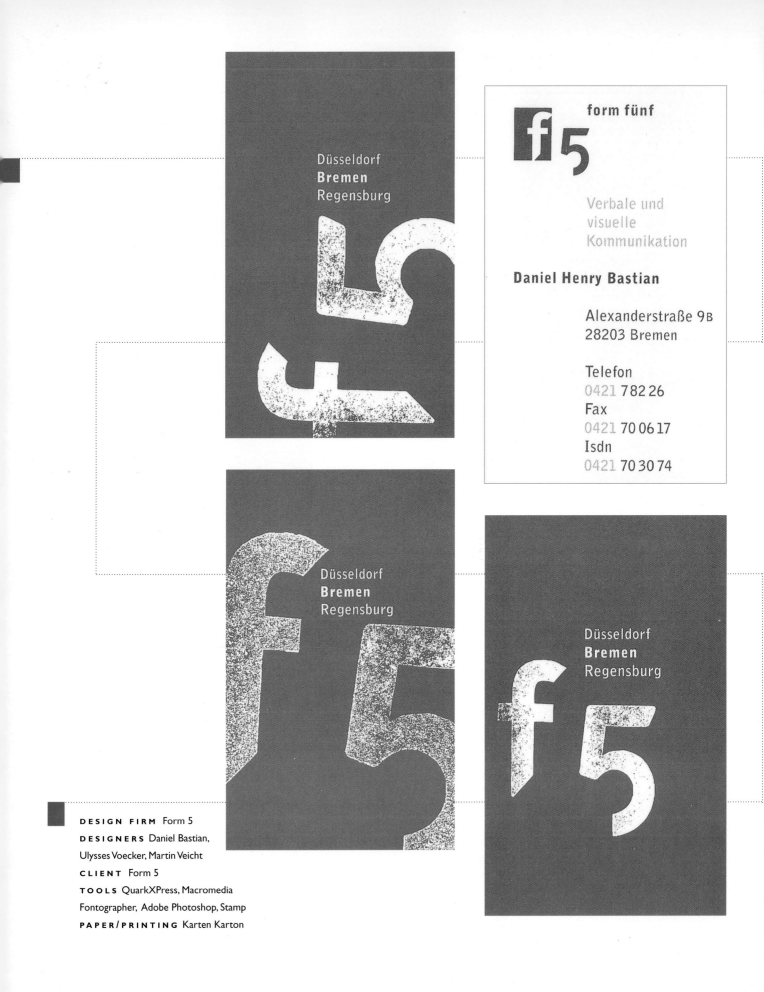

form fünf

f5

Verbale und
visuelle
Kommunikation

Daniel Henry Bastian

Alexanderstraße 9B
28203 Bremen

Telefon
0421 782 26
Fax
0421 70 06 17
Isdn
0421 70 30 74

Düsseldorf
Bremen
Regensburg

Düsseldorf
Bremen
Regensburg

Düsseldorf
Bremen
Regensburg

DESIGN FIRM Form 5
DESIGNERS Daniel Bastian,
Ulysses Voecker, Martin Veicht
CLIENT Form 5
TOOLS QuarkXPress, Macromedia
Fontographer, Adobe Photoshop, Stamp
PAPER/PRINTING Karten Karton

DESIGN FIRM The Design Company
ART DIRECTOR/ILLUSTRATOR Marcia Romanuck
CLIENT E. Claire Therapy
PAPER/PRINTING Champion Carnival Wove

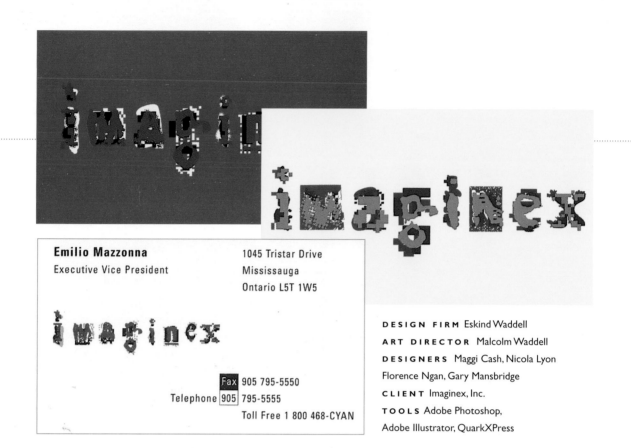

Emilio Mazzonna
Executive Vice President

1045 Tristar Drive
Mississauga
Ontario L5T 1W5

Fax 905 795-5550
Telephone 905 795-5555
Toll Free 1 800 468-CYAN

DESIGN FIRM Eskind Waddell
ART DIRECTOR Malcolm Waddell
DESIGNERS Maggi Cash, Nicola Lyon
Florence Ngan, Gary Mansbridge
CLIENT Imaginex, Inc.
TOOLS Adobe Photoshop,
Adobe Illustrator, QuarkXPress

Belluno Ristorante

340 Lexington Avenue • New York, NY 10016
Between 39th & 40th Streets
(212) 953-3282

DESIGN FIRM Rick Eiber Design (RED)
ART DIRECTOR/DESIGNER Rick Eiber
CLIENT Mindshare Media
PAPER/PRINTING Engraved, offset yellow

DESIGN FIRM Angry Porcupine Design
DESIGNER/ILLUSTRATOR Cheryl Roder-Quill
CLIENT Cheryl Roder-Quill
TOOLS Macintosh, QuarkXPress

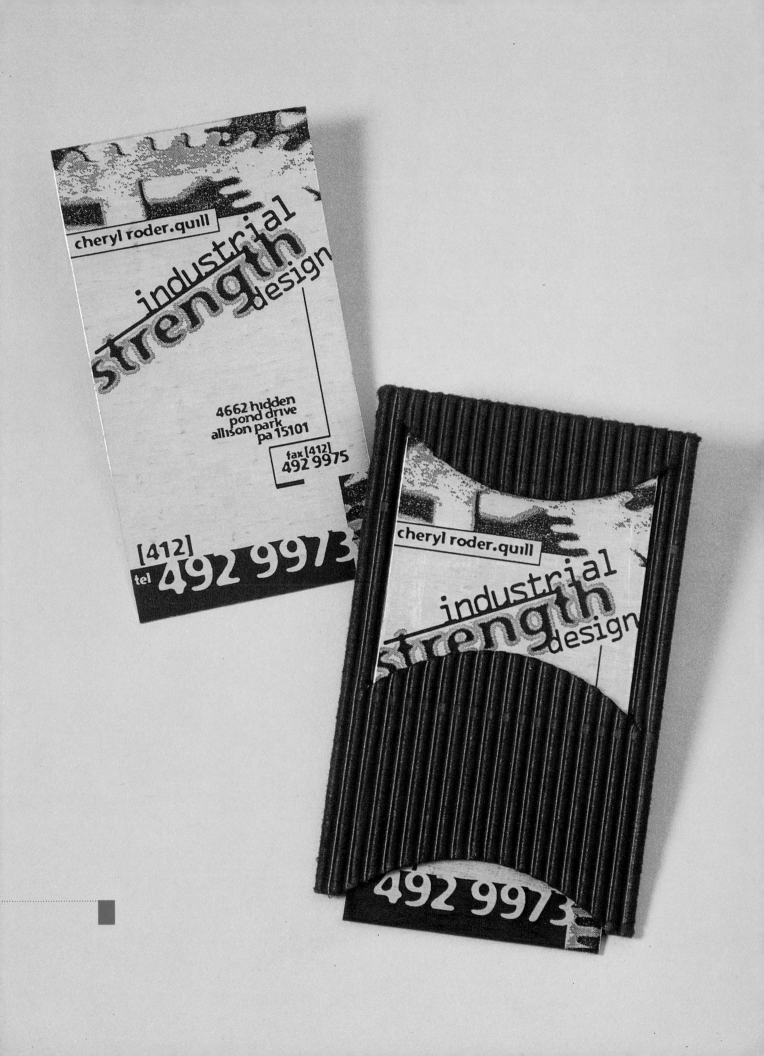

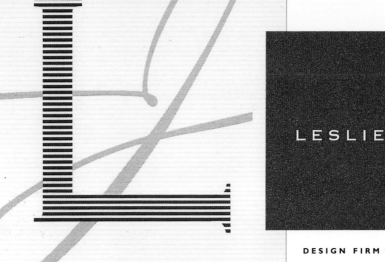

JIM WILKIRSON
DESIGNER / CONSULTANT

INTERIORS • OCCASIONS • FASHION

2159 SOUTHWOOD ROAD • JACKSON, MISSISSIPPI 39211
601-362-1777 • FAX 601-362-7788

DESIGN FIRM Communication Arts Company

ART DIRECTOR/DESIGNER Hilda Stauss Owen

CLIENT Leslie James, Ltd.

TOOLS Macintosh

PAPER/PRINTING Strathmore Elements/Offset lithography

DESIGN FIRM M-DSIGN

ALL DESIGN Mika Ruusunen

CLIENT Marika Saarinen

TOOLS Macintosh

PAPER/PRINTING Offset

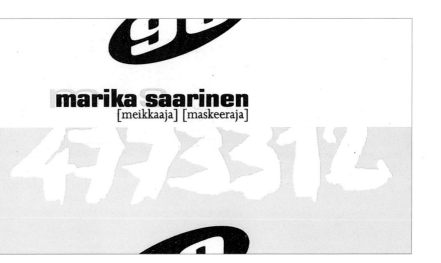

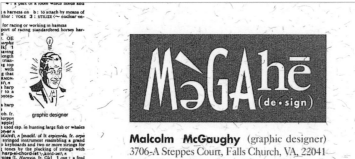

DESIGN FIRM McGaughy Design

ART DIRECTOR/DESIGNER Malcolm McGaughy

CLIENT McGaughy Design

TOOLS Macromedia FreeHand

PAPER/PRINTING Tuscan Terra, Alabaster/
Two color offset

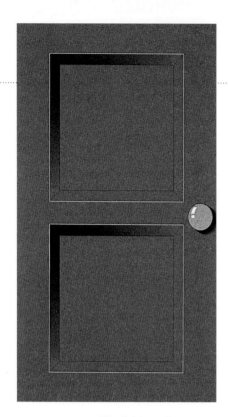

The Village
1616
Butler Avenue
West Los Angeles CA
90025
PHONE 310. 478. 8227
FAX 310. 479. 1142
E•MAIL villagerec@aol.com

Julie Hormel
President

DESIGN FIRM Mike Salisbury Communications
ART DIRECTOR Mike Salisbury
DESIGNER Mary Evelyn McGough
CLIENT Village Recorder

PLATINUM DESIGN, INC.

PLATINUM 14 West 23rd St., New York, NY 10010
tel: 212-366-4000 fax: 212-366-4046

Victoria Peslak, President

DESIGN FIRM Platinum Design, Inc.
ART DIRECTOR/DESIGNER Victoria Stamm
CLIENT Platinum Design, Inc.
TOOLS Power Macintosh 8100
PAPER/PRINTING Starwhite/Vicksburg

Heine, Buchhandlung

Tanja Ringewaldt Lange Straße 19
29664 Walsrode
Telefon 05161 91 01 51
Telefax 05161 91 01 73

DESIGNERS Daniel Bastian, Andreas Weiss
CLIENT Heine, Buchhandlung
TOOLS QuarkXPress
PAPER/PRINTING Conquerdor/Offset

Gil Rubén García Bautista
General Manager

Obispo Visitador No.48
Col. Fray Antonio de San Miguel
Morelia, Michoacán, México
Tel. (43) 15 96 77

DESIGN FIRM Animus Comunicaçáo
ART DIRECTOR Rique Nitzsche
DESIGNER Victal Caesar
CLIENT Neisa Nitzsche Teixeira
TOOLS Macromedia FreeHand,
Adobe Photoshop
PAPER/PRINTING
Opaline 180 gsm/Five color

Andreas Bastian
Caro Fotoagentur
12051 Berlin
Nogatstraße 14
Telefon 030 687 25 36
Telefax 030 686 01 62

DESIGN FIRM Büro B.
DESIGNER Daniel Bastian
CLIENT Caro Fotoagentur
TOOLS QuarkXPress
PAPER/PRINTING Karten
Karton/Offset

AERO INTERNET SERVICES, INC.

æRŌ

Thomas F.E. Rutter
Vice President of
Education & Training

tom@aeroinc.net
www.aeroinc.net

130 West Main Street, Suite A
P.O. Box 585
Lena, Illinois 61048
(815) 369 4414
Fax: (815) 369 4833

DESIGN FIRM Tanagram
DESIGNER Lance Rutter
CLIENT Aero Internet Services
TOOLS Macromedia FreeHand

GRAND SLAM
©1995
Sports, Entertainment, Special Event
& Licensing Representation

JEREMY A. STEPHAN
Director of Sales, Worldwide

401 PENNSYLVANIA PKWY | SUITE 390
INDIANAPOLIS, INDIANA | 46280
MAIN | 317 575 5900
DIRECT | 317 **575 5906**
FAX | 317 575 5650

DESIGN FIRM Held Diedrich
ART DIRECTOR Dick Held
DESIGNER Sander Leech
CLIENT Grand Slam
TOOLS Adobe Illustrator, QuarkXPress
PAPER/PRINTING Neenah, Classic Crest,
Solar White/Offset

JEAN E. FRANZ

8403 COLESVILLE ROAD
SUITE 865
SILVER SPRING, MD 20910
(301) 589.7199
FAX (301) 495.4959

FRANZ & COMPANY, INC.

DESIGN FIRM Steve Trapero Design
ART DIRECTOR/DESIGNER Steve Trapero
CLIENT Franz & Company, Inc.
TOOLS QuarkXPress, Adobe Illustrator
PAPER/PRINTING Graphica Lineal/Two-color offset

4530 West Pine
Suite 100
St. Louis, MO
63108

MARY McELWAIN

314 361 3701

DESIGN FIRM Bartels & Company, Inc.
ART DIRECTOR David Bartels
DESIGNER/ILLUSTRATOR Aaron Segall
CLIENT McElwain Fine Arts
PAPER/PRINTING Mid West Printing

DESIGN FIRM Mike Salisbury Communications
ART DIRECTOR Mike Salisbury
DESIGNER Mary Evelyn McGough
CLIENT Mike Salisbury

DESIGN FIRM Bartels & Company, Inc.
ART DIRECTOR David Bartels
DESIGNER/ILLUSTRATOR Bob Thomas
CLIENT Bartels & Company, Inc.
PAPER/PRINTING Chromecoat/Devere Printing

HIROKO TANAKA
One Irving Place U-12b
New York, NY 10003
Tel 212·995·8489 Fax 212·254·8233

DESIGN FIRM Mirko Ilić Corp.
ART DIRECTOR/DESIGNER Nicky Lindeman
CLIENT Mirko Ilić Corp.
TOOLS QuarkXPress
PAPER/PRINTING Cougar Smooth white
80 lb. cover/Rob-Win Press

DESIGN FIRM
Carl Chiocca Creative Designs
ALL DESIGN
Carl Chiocca
TOOLS
Adobe Photoshop, QuarkXPress
PAPER/PRINTING
Lustro Gloss 80 lb. cover/
Two color offset

CARL CHIOCCA
CREATIVE DESIGNS
& PRINT PRODUCTION

10 renwick street pittsburgh pa 15210

PHONE 412 431·2095 FACSIMILE 412 431·7750

DESIGN FIRM M-DSIGN
ALL DESIGN Mika Ruusunen
CLIENT M-DSIGN
TOOLS Macintosh
PAPER/PRINTING Offset

DESIGN FIRM Judy Wheaton
ART DIRECTOR/DESIGNER Judy Wheaton
ILLUSTRATOR Creative Collection
CLIENT Al-Pack
TOOLS Adobe Photoshop, Adobe PageMaker
PAPER/PRINTING Classic Laid/TK Printing

DESIGN FIRM On The Edge
ART DIRECTOR Jeff Gasper
DESIGNER Jon Nedry
ILLUSTRATOR Robert Wilhelm
CLIENT Chimayo Grill
TOOLS Adobe Illustrator, QuarkXPress, Adobe Photoshop
PAPER/PRINTING Luna White coated/Four color

ALL DESIGN James Marsh
CLIENT James Marsh
TOOLS Acrylic
PAPER/PRINTING Four color

DESIGN FIRM Charney Design
ART DIRECTOR/DESIGNER Carol Inez Charney
ILLUSTRATOR Kim Ferrell
CLIENT Village Bakehouse
TOOLS Adobe Illustrator, Adobe Photoshop
PAPER/PRINTING Environment/Offset

DESIGN FIRM Kerrickters
ALL DESIGN Christine Kerrick
CLIENT Christine Kerrick
TOOLS Graphite, Adobe Illustrator

DESIGN FIRM Animus Comunicaçáo
ART DIRECTOR Rique Nitzsche
DESIGNER Victal Caesar
CLIENT Jade Carvalhido
TOOLS Macromedia FreeHand, Adobe Photoshop
PAPER/PRINTING Opaline 180 gsm/Four color

DESIGN FIRM Val Gene Associates
ART DIRECTOR/DESIGNER Lacy Leverett
ILLUSTRATOR Christopher Jennings
CLIENT Dockside
PAPER/PRINTING Baker's Printing

DESIGN RANCH

Gary H. Gnade
Pardner

701 East Davenport Street
Iowa City, Iowa
52245.2812
319.354.2623
FAX 319.354.6077

DESIGN FIRM
Design Ranch
ART DIRECTOR/DESIGNER
Gary Gnade
CLIENT
Design Ranch

VGA

Lacy Leverett
Advertising Director

Val Gene Associates
5208 Classen Blvd.
Oklahoma City, Oklahoma
73118
TEL 405-843-9474
FAX 405-842-5063

DESIGN FIRM Val Gene Associates
ALL DESIGN Lacy Leverett
PRODUCTION Shirley Morrow
CLIENT Val Gene Associates
PAPER/PRINTING Baker's Printing

JUDY WHEATON

Graphic *Designer* Graphiste
MGDC

52 Wheaton
Moncton
NB
Canada
E1E 2K2
(506)
389-8602

JUDY WHEATON

Graphic *Designer* Graphiste
MGDC

52 Wheaton
Moncton
NB
Canada
E1E 2K2
(506)
389-8602

DESIGN FIRM Judy Wheaton
ART DIRECTOR/DESIGNER Judy Wheaton
CLIENT Judy Wheaton
TOOLS Adobe PageMaker
PAPER/PRINTING Kromekote/TK Printing

Tracy Griffin Sleeter

RR 22 BOX 6
BUTCHER'S LANE
BLOOMINGTON, IL 61701
email: dirtrac@aol.comm
fax: 309-828-9795

309•829•4295

Tracy Griffin Sleeter

Graphic Design & Illustration
309•829•4295

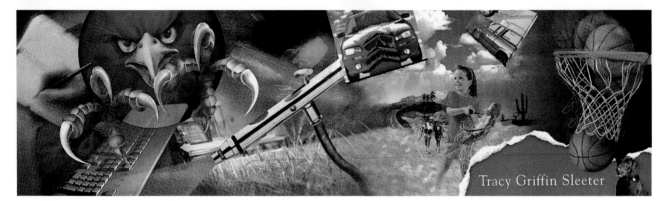

Tracy Griffin Sleeter

DESIGN FIRM Tracy Griffin Sleeter

DESIGNER/ILLUSTRATOR Tracy Griffin Sleeter

CLIENT Tracy Griffin Sleeter

TOOLS Adobe Photoshop, Adobe Illustrator, QuarkXPress

PAPER/PRINTING Trophy Dull Cover/Stamet Indigo Press

DESIGN FIRM
Ninja Design
ART DIRECTOR/DESIGNER
Nina Merzbach
CLIENT Ninja Design
TOOLS Macintosh,
Adobe Photoshop,
QuarkXPress
PAPER/PRINTING
Colorado Printing Company

EVERY BUSINESS NEEDS A...

NINJA

NINJA
DESIGN

REATIVE MARKETING
KILLER GRAPHICS

NINA MERZBACH

Tel & Fax: 970•925•2393

P.O. Box 3465

Aspen, Colorado 61612

E-Mail: nina @ ninja-design.com

DESIGN FIRM Designing Concepts

DESIGNERS Renee Sheppard, Mariah Parker

CLIENT Karl Danskin

TOOLS QuarkXPress, Adobe Photoshop, Adobe Illustrator

PAPER/PRINTING Marin Stat

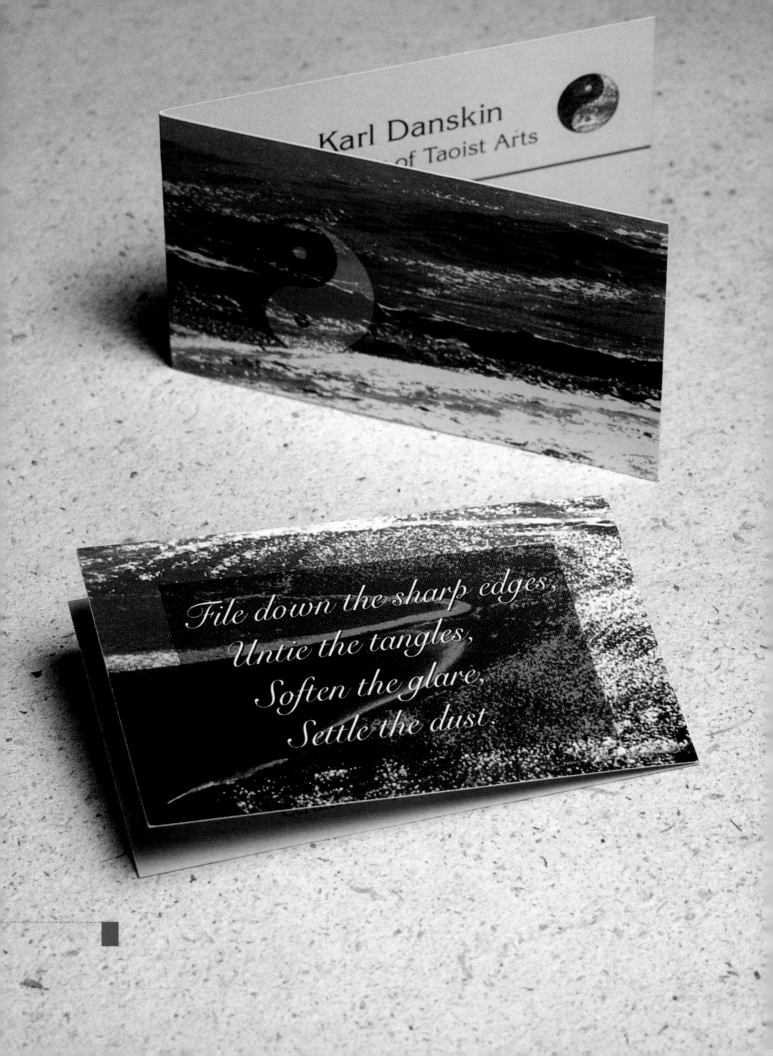

Karl Danskin
of Taoist Arts

File down the sharp edges,
Untie the tangles,
Soften the glare,
Settle the dust.

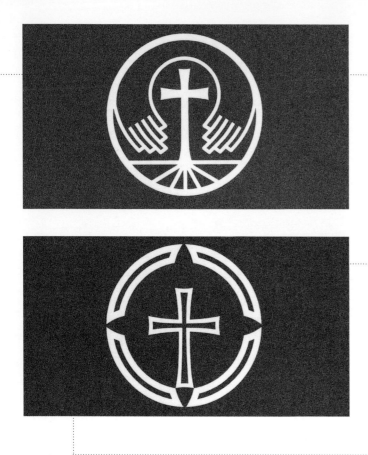

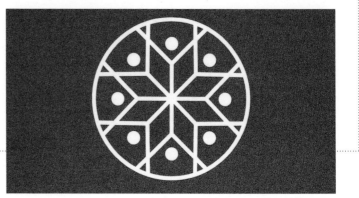

STRATEGIC CHURCH PLANTING

7913 N.E. 58TH AVENUE
VANCOUVER, WA 98665

TEL 360.694.4985
FAX 360.694.0219

MATT HANNAN
DIRECTOR OF CHURCH PLANTING
COLUMBIA BAPTIST CONFERENCE

DESIGN FIRM Rick Eiber Design (RED)
ART DIRECTOR Rick Eiber
CLIENT Columbia Baptist Conference
PAPER/PRINTING Brightwater/Two colors over two colors

GOLF TV

SUZANNE STEEVES
SENIOR VICE-PRESIDENT
AND GENERAL MANAGER

● ● ● ● ● ● ●

P.O. BOX 9, STATION "O",
TORONTO, ONTARIO, CANADA M4A 2M9
TEL: (416) 299-2070
FAX: (416) 299-2076

DESIGN FIRM
BBS In House Design
ALL DESIGN
Joyce Woollcot
CLIENT
BBS/Golf TV
TOOLS
Adobe Illustrator
PAPER/PRINTING
Strathmore Elements Dots

SUSAN BIERZYCHUDEK
SENIOR ACCOUNTS DIRECTOR

A X I O N image solutions for brand success

415 258 6807 **T**
415 457 8227 **F**
susanb@axionsf.com **e**

DESIGN FIRM Axion Design, Inc.
ART DIRECTOR/DESIGNER Kenn Lewis
CLIENT Axion Design
TOOLS Adobe Illustrator
PAPER/PRINTING Environment Ivory 80 lb./Offset, embossed

GEORGE G. GENTILE
& ASSOCIATES, INC.
Landscape Architects,
Planners and
Environmental Consultants

Melissa A. Kilpatrick
Office Administrator

675 West Indiantown Road
Suite 201
Jupiter, Florida 33458
561-575-9557
561-575-5260 FAX

GEORGE G. GENTILE
& ASSOCIATES, INC.
Landscape Architects,
Planners and
Environmental Consultants

Jason M. Litterick
Designer

675 West Indiantown Road
Suite 201
Jupiter, Florida 33458
561-575-9557
561-575-5260 FAX

GEORGE G. GENTILE
& ASSOCIATES, INC.
Landscape Architects,
Planners and
Environmental Consultants

George G. Gentile
FASLA, President

675 West Indiantown Road
Suite 201
Jupiter, Florida 33458
561-575-9557
561-575-5260 FAX

DESIGN FIRM
George G. Gentile & Associates
TOOLS
CorelDraw

Kristin Rankin, MA, CCC-A

*The Center for
Better Hearing*

*Audiology &
Hearing Instruments*

3550 Lutheran Pkwy. West, #102B
Wheat Ridge, Colorado 80033
303.**425.0449** Fax: 425.4086

DESIGN FIRM Brainstorm!
DESIGNER Bob Downs
CLIENT The Center for Better Hearing
TOOLS Macromedia FreeHand, Macintosh
PAPER/PRINTING Quest/Black and silver foil

Cristina Gerwitz

Lakewood, Ohio ◆ 44107

17109 Hilliard Blvd. ◆

d**ESIGNER**
216 . 226 .7561

GRAPHICS
PRODUCTS

DESIGN FIRM
Christina Design
DESIGNER
Christina Gerwitz
TOOLS
Macromedia FreeHand
PAPER/PRINTING
Neenah/Two color

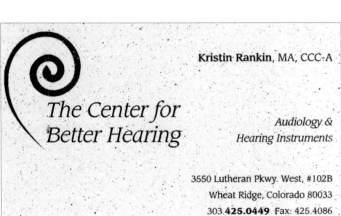

PORCELLI DESIGN

Lael Porcelli 24 Webster Place Port Chester NY 10573 **914 934 1658**

DESIGN FIRM Porcelli Design
ALL DESIGN Lael Porcelli
CLIENT Porcelli Design
TOOLS Adobe Illustrator, Adobe Streamline
PAPER/PRINTING Natural Fiber Recycled/Ink jet

EYE MEDICAL CLINIC
50 yrs
1946-1996

220 Meridian Avenue
San Jose, California
9 5 1 2 6

Patricia S. Cunnane
Manager

408.494.0500

APPOINTMENTS
408.494.0525

BUSINESS OFFICE
408.494.0555

OPTICAL DEPARTMENT
408.494.0510

FAX
408.947.7972

DESIGN FIRM Jill Morrison Design
ALL DESIGN Jill Morrison
CLIENT Eye Medical Clinic
TOOLS Macromedia FreeHand, QuarkXPress
PAPER/PRINTING Three color

LO♥EABLE
CHOCOLATES

Toll-Free
Tel. (800) 558-9898
Fax (800) 558-6896

Karen L. Klein

Loveable Chocolates
155 East Sunset Way
Issaquah, WA 98027

Tel. (206) 313-0443
Fax (206) 313-0463

B² Designs

Carol Benthal-Bingley • Graphic Designer
220 S. 5th St., DeKalb, Illinois 60115 • (815) 748-5776
cbenthal@niu.edu

DESIGN FIRM Rick Eiber Design (RED)
ART DIRECTOR Rick Eiber
DESIGNER David Balzer
CLIENT Loveable Chocolates
PAPER/PRINTING Speckletone/
Two-color offset

DESIGN FIRM B² Designs
ALL DESIGN Carol Benthal-Bingley
TOOLS Adobe Photoshop, Adobe PageMaker
PAPER/PRINTING Creekside Printing

DESIGN FIRM Drake & Boucher
DESIGNERS Jon Livington, Kiki Boucher
CLIENT Adjil & Bloomberg LIC
TOOLS QuarkXPress
PAPER/PRINTING Strathmore Writing cover/
Three color

GULLANS

JOAN GULLANS

Gullans International, Inc.
22 Elizabeth Street South Norwalk, CT 06854
Tel (203) 838-5449 Fax (203) 838-5905

DESIGN FIRM Greteman Group
ART DIRECTORS/DESIGNERS Sonia Greteman, James Strange
CLIENT Austin Miller Engineering Services
TOOLS Macromedia FreeHand
PAPER/PRINTING Genesis/Two-color offset

DESIGN FIRM Sivustudio
ART DIRECTOR Jaana Aartomaa
CLIENT Kim Haukatsalo
TOOLS Macromedia FreeHand, Macintosh
PAPER/PRINTING Flannel/Offset

DESIGN FIRM D2 Design
ALL DESIGN Dominique Duval
CLIENT D2 Design
TOOLS Adobe Illustrator, Adobe Photoshop, Macintosh
PAPER/PRINTING Two-color offset

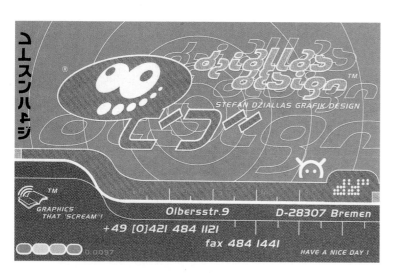

Mark D. Emerson
President

2910 Stevens Creek Blvd.
Suite 109-1845
San Jose, CA 95128-2015
voice mail 408-599-0816
ph 408-972-9103 fx 408-226-9324

DESIGN FIRM
JWK Design Group, Inc.
ALL DESIGN Jennifer Kompolt
CLIENT Maternal Concepts Ltd.
TOOLS Adobe Illustrator
PAPER/PRINTING Simpson
Evergreen Script Aspen

THOMAS SUZUKI, O.D.

DESIGN FIRM Design Source
ALL DESIGN Cari Johnson
CLIENT Dr. Thomas Suzuki
TOOLS Adobe Illustrator
PAPER/PRINTING Karma
Natural/Two-color offset

53 ASPEN WAY
WATSONVILLE, CA 95076
PHONE 408 724-1097
FAX 408 724-6364

11272 MERRITT ST., SUITE D
CASTROVILLE, CA 95012
408 633-0550

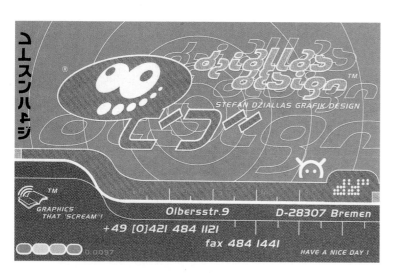

DESIGN FIRM Stefan Dziallas Design
DESIGNER/ILLUSTRATOR Stefan Dziallas
CLIENT Stefan Dziallas
TOOLS Adobe Photoshop, QuarkXPress, Macintosh
PAPER/PRINTING 300gsm Matt/Schneidersöhne

DESIGN FIRM Apple Graphics &
Advertising of Merrick, Inc.
DESIGNER Allison Blair Schneider
CLIENT The Aroma Boutique
TOOLS Macromedia FreeHand,
Power Macintosh 7500
PAPER/PRINTING Fox River Circa Select
Moss/One-color themography

SPRING HOLLOW

CRAIG OVERMYER,
D.Min.

2750 S. 875 E
Zionsville, IN
46077.9526

317.
769.
6839

DESIGN FIRM
Held Diedrich
ART DIRECTOR
Doug Diedrich
DESIGNER/ILLUSTRATOR
Megan Snow
CLIENT
Spring Hollow
TOOLS
QuarkXPress, Adobe Illustrator
PAPER/PRINTING
Neenah, Classic Laid,
Natural White/Offset

OLIVE TREE
DESIGN, DISPLAY & ARTWORK

Ann & Alan Olive
12 Glen St Coorparoo Qld 4151
Telephone: (07) 3397 8732
Mobile: (0419) 733 752

DESIGN FIRM Olive Tree
ART DIRECTOR/DESIGNER Alan Olive
ILLUSTRATOR Kent Smith
TOOLS CorelDraw
PAPER/PRINTING Edwards Dunlop
Recycled Evergreen

CUSTOM SAFETY FLOOR MATTING

sbemco

INTERNATIONAL, INC.
715 NORTH FINN DRIVE ALGONA, IOWA 50511

BRIAN BUSCHER
President

TEL. (515)295-3902
(800)468-0860
FAX: (515)295-9545

DESIGN FIRM Sayles Graphic Design
ALL DESIGN John Sayles
CLIENT Sbemco International
PAPER/PRINTING Curtis Retreeve white/Offset

2200 Sixth Avenue
Suite 1103
Seattle, WA 98121

GARDNER GRAPHICS

g

P / FAX: (206) 441-8914 (By Appt.)

DESIGN FIRM Gardner Graphics
ALL DESIGN Dianne Gardner
CLIENT Dianne Gardner
TOOLS Adobe Photoshop
PAPER/PRINTING Coated

KRISTY ANN KUTCH

Colored Pencil Artwork/Instruction
11555 West Earl Road
Michigan City, IN 46360

219 · 874 · 4688

Berry Bounty, 16" x 18"

DESIGN FIRM Kristy A. Kutch
ILLUSTRATOR Kristy A. Kutch
TOOLS Colored pencil painting
PAPER/PRINTING Perfect Picture

PROGRESSIVE **C**ENTER
FOR **I**NDEPENDENT **L**IVING INC.

MEG NORTH
EXECUTIVE DIRECTOR

831 PARKWAY AVENUE, B-2
EWING, NJ 08618
PHONE: (609) 530-0006
FAX: (609) 530-1166
TTY: (609) 530-1234

DESIGN FIRM Howard Levy Design
ART DIRECTOR/DESIGNER Howard Levy
CLIENT Progressive Center for Independent Living, Inc.
TOOLS QuarkXPress, Adobe Illustrator
PAPER/PRINTING Two-color offset

Complete Street Rod Chassis and Suspension
3045 Jefferson St. • San Diego, CA 92110 • 619 293 0834

Gary Timm

DESIGN FIRM Mires Design
ART DIRECTOR/DESIGNER John Ball
ILLUSTRATOR Tracy Sabin
CLIENT Gary's Hot Rods

DESIGN FIRM Keiler Design Group
ART DIRECTOR Jeff Lin
DESIGNERS Jeff Lin, Mandy Rohde
ILLUSTRATOR Jim Coon
CLIENT Matt Rohde
TOOLS Adobe Photoshop

matt rohde

keyboardist/pianist

5540 roswell road
unit E201
sandy springs,
GA 30342

404·303·7735

DESIGN FIRM Bartels & Company, Inc.
ART DIRECTOR David Bartels
DESIGNER/ILLUSTRATOR
John Postlewait
CLIENT Cheapy Smokes
PAPER/PRINTING Mid West Printing

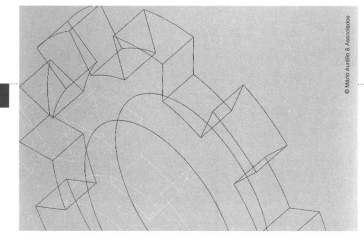

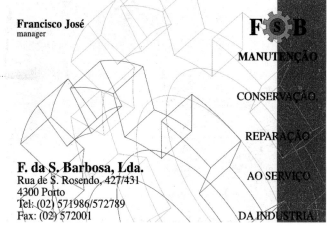

DESIGN FIRM MA&A—Mário Aurélio & Associados
ART DIRECTOR Mário Aurélio
DESIGNERS Mário Aurélio, Rosa Maia
CLIENT F.S.B.

DESIGN FIRM
Abrams & LaBrecque Design
ALL DESIGN Ed Abrams, Elisée LaBrecque
CLIENT Mostue & Assoc. Architects, Inc.
TOOLS QuarkXPress
PAPER/PRINTING Strathmore Pure
Cotton/Benjamin Franklin Smith

DESIGN FIRM The Eikon Marketing Team
ALL DESIGN Dannah Gresh
CLIENT K-DAY 97.5
TOOLS Macromedia FreeHand
PAPER/PRINTING Beckett Laid white

THE TRUE BLUE COMPANY

TRUE
BLUE

BRIAN LIPNER
PRESIDENT

939 WEST HURON, No.108
CHICAGO, ILLINOIS 60622
PHONE 312.563.9944
FAX 312.563.0125
E-MAIL BLIPNER@AOL

DESIGN FIRM Michael Stanard Design, Inc.
ART DIRECTOR Michael Stanard
DESIGNER Kristy Vandekerckhove
CLIENT Brian Lipner/The True Blue Co.
PAPER/PRINTING Strathmore Renewal/Offset

DESIGN FIRM Carl D. J. Ison
ART DIRECTOR/DESIGNER Carl D. J. Ison
CLIENT Carl D. J. Ison
TOOLS QuarkXPress, Adobe Illustrator, Adobe Photoshop
PAPER/PRINTING One color on two sides, various metal
and alloy 3D tip ons: eyelet, nut/bolt, and lead discs

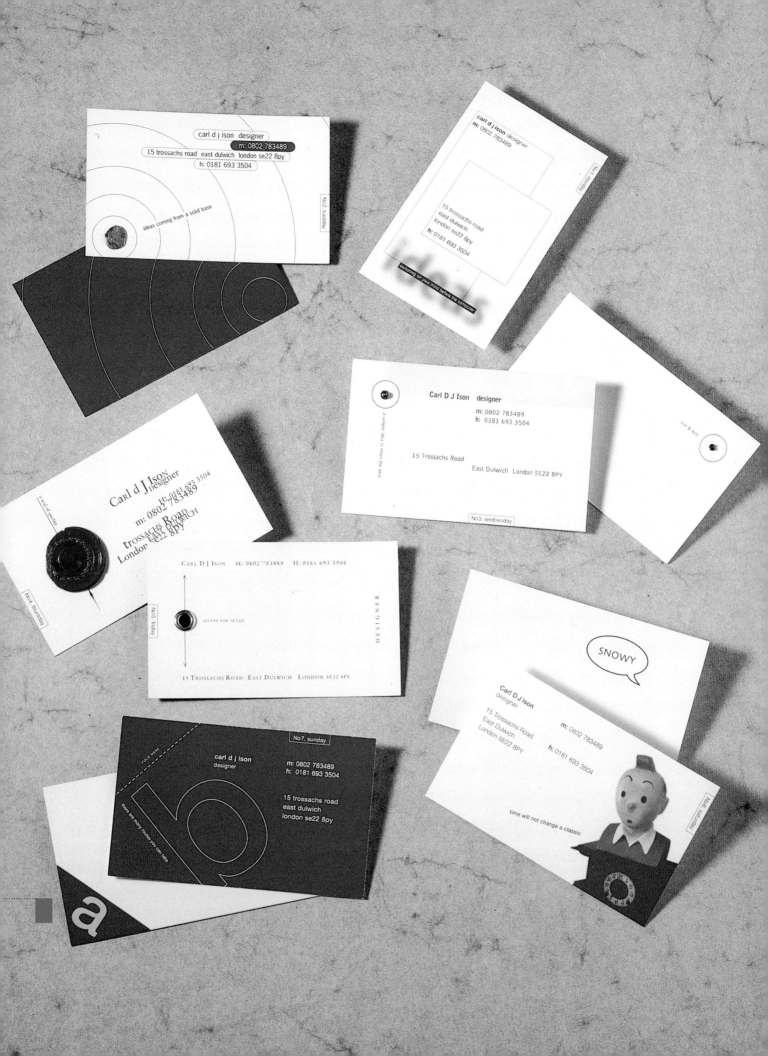

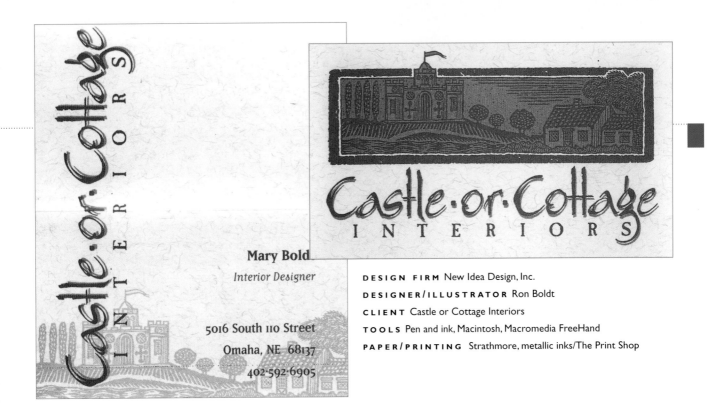

Mary Bold

Interior Designer

5016 South 110 Street
Omaha, NE 68137

402·592·6905

DESIGN FIRM New Idea Design, Inc.
DESIGNER/ILLUSTRATOR Ron Boldt
CLIENT Castle or Cottage Interiors
TOOLS Pen and ink, Macintosh, Macromedia FreeHand
PAPER/PRINTING Strathmore, metallic inks/The Print Shop

DESIGN FIRM Jon Nedry
ALL DESIGN Jon Nedry
CLIENT Classic Cigar Company
TOOLS Adobe Illustrator, QuarkXPress
PAPER/PRINTING Neenah Environment,
Cover Duplex, Desert Storm/Alpaca

DESIGN FIRM Jane Dill Calligraphy & Design
ART DIRECTORS/DESIGNER Jane Dill
CLIENT Jane Dill
TOOLS Brush, type
PAPER/PRINTING Benefit Champion/blind
emboss, foil stamp

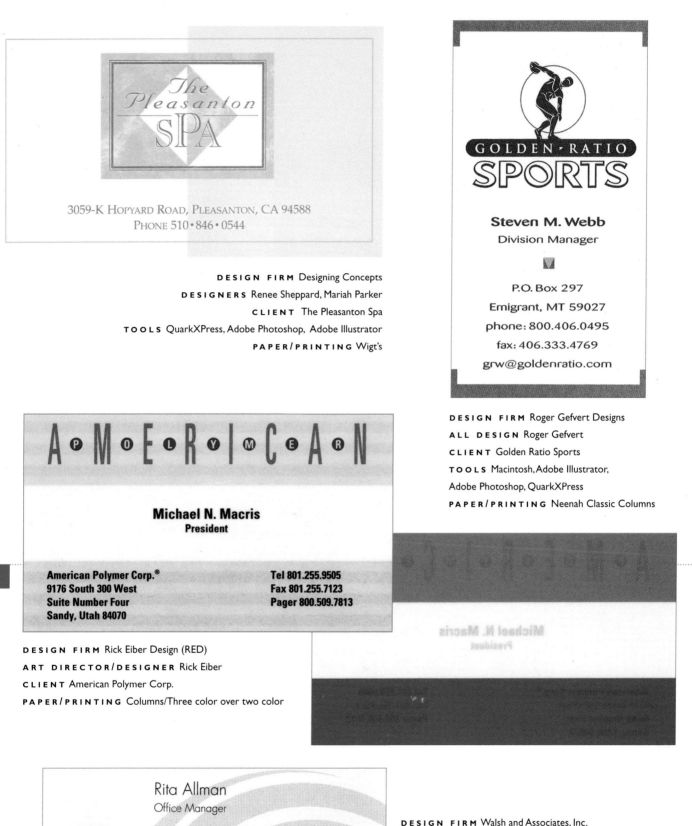

The Pleasanton SPA

3059-K HOPYARD ROAD, PLEASANTON, CA 94588
PHONE 510•846•0544

DESIGN FIRM Designing Concepts
DESIGNERS Renee Sheppard, Mariah Parker
CLIENT The Pleasanton Spa
TOOLS QuarkXPress, Adobe Photoshop, Adobe Illustrator
PAPER/PRINTING Wigt's

GOLDEN·RATIO
SPORTS

Steven M. Webb
Division Manager

P.O. Box 297
Emigrant, MT 59027
phone: 800.406.0495
fax: 406.333.4769
grw@goldenratio.com

DESIGN FIRM Roger Gefvert Designs
ALL DESIGN Roger Gefvert
CLIENT Golden Ratio Sports
TOOLS Macintosh, Adobe Illustrator,
Adobe Photoshop, QuarkXPress
PAPER/PRINTING Neenah Classic Columns

A•M•E•R•I•C•A•N
P O L Y M E R

Michael N. Macris
President

American Polymer Corp.® Tel 801.255.9505
9176 South 300 West Fax 801.255.7123
Suite Number Four Pager 800.509.7813
Sandy, Utah 84070

DESIGN FIRM Rick Eiber Design (RED)
ART DIRECTOR/DESIGNER Rick Eiber
CLIENT American Polymer Corp.
PAPER/PRINTING Columns/Three color over two color

Rita Allman
Office Manager

EXECUTIVE DIVERSITY
SERVICES, INC.

675 South Lane Street, Suite 305
Seattle, WA 98104-2942
(206) 224-9293 • Fax (206) 224-9303

DESIGN FIRM Walsh and Associates, Inc.
ART DIRECTOR/DESIGNER Miriam Lisco
CLIENT Executive Diversity Services
TOOLS Adobe Illustrator, Adobe PageMaker
PAPER/PRINTING Classic Crest Natural White/A & A Printing

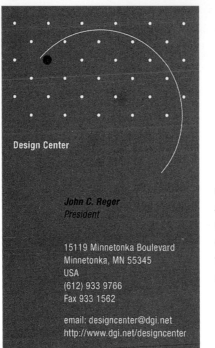

Design Center

John C. Reger
President

15119 Minnetonka Boulevard
Minnetonka, MN 55345
USA
(612) 933 9766
Fax 933 1562

email: designcenter@dgi.net
http://www.dgi.net/designcenter

DESIGN FIRM Design Center
ART DIRECTOR John Reger
DESIGNER Dick Stanley
CLIENT Design Center
TOOLS Macintosh
PAPER/PRINTING Procraft Printing

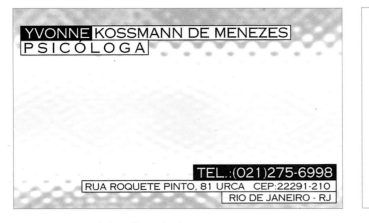

DESIGN FIRM Animus Comunicaçáo
ART DIRECTOR Rique Nitzsche
DESIGNER Wiz Henrique Londres
CLIENT Yvonne Kossmann Demenezes
TOOLS Macromedia FreeHand, Adobe Photoshop
PAPER/PRINTING Opaline 180 gsm/Four color

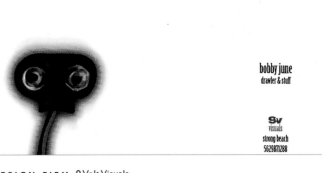

DESIGN FIRM 9 Volt Visuals
ART DIRECTOR/DESIGNER Bobby June
PHOTOGRAPHER Jason Nadeau
CLIENT 9 Volt Visuals
TOOLS Adobe Photoshop, Adobe Illustrator
PAPER/PRINTING Twin Concepts

DESIGN FIRM Animus Comunicaçáo
ART DIRECTOR Rique Nitzsche
DESIGNER Victal Caesar
CLIENT Neisa Nitzsche Teixeira
TOOLS Macromedia FreeHand, Adobe Photoshop
PAPER/PRINTING Opaline 180 gsm/Four color

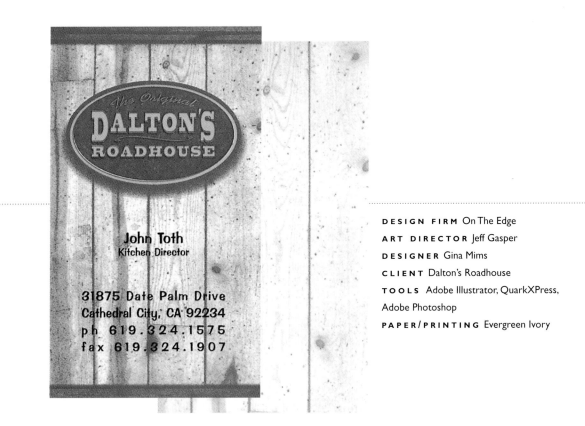

John Toth
Kitchen Director

31875 Date Palm Drive
Cathedral City, CA 92234
ph 619.324.1575
fax 619.324.1907

DESIGN FIRM On The Edge
ART DIRECTOR Jeff Gasper
DESIGNER Gina Mims
CLIENT Dalton's Roadhouse
TOOLS Adobe Illustrator, QuarkXPress, Adobe Photoshop
PAPER/PRINTING Evergreen Ivory

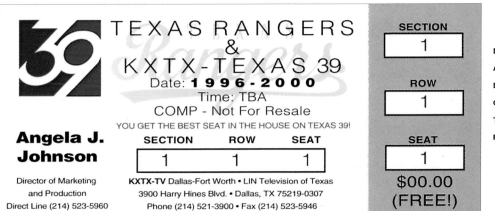

DESIGN FIRM KXTX Marketing Dept.
ART DIRECTOR David Wells
DESIGNER Kelly Cavener
CLIENT KXTX-TV 39
TOOLS Adobe Illustrator
PAPER/PRINTING CIS/The Ad Place

DESIGN FIRM Designing Concepts
DESIGNERS Renee Sheppard, Mariah Parker
CLIENT Melanie Tarkenton
TOOLS Adobe Illustrator
PAPER/PRINTING Tam Print

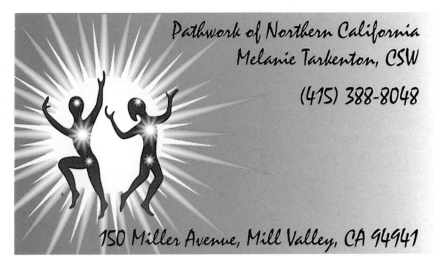

THE
PAUL MARTIN
design
COMPANY

THE
PAUL MARTIN
design
COMPANY

32 Dragon Street
Petersfield
Hampshire GU31 4JJ

telephone
01730 265814
facsimile
01730 263014
ISDN
01730 261392

PAUL MARTIN MA(RCA) FCSD
Creative Director

DESIGN FIRM The Paul Martin Design Co.
ART DIRECTOR Paul Martin
DESIGNER Paul Adams
CLIENT The Paul Martin Design Co.
PAPER/PRINTING Huntsman Velvet
300 gsm/St. Richard's Press

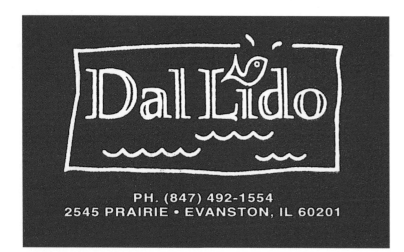

DESIGN FIRM Bullet Communications, Inc.
ALL DESIGN Tim Scott
CLIENT Dal Lido Restaurant
TOOLS QuarkXPress, Adobe Illustrator
PAPER/PRINTING Carolina 8 pt. cover/Offset

kersten hanke

diplom-designer

viktoriastraße 46

52066 aachen

fon-fax 02 41 - 50 42 50

DESIGN FIRM Hanke Kommunikation
ART DIRECTOR Kersten Hanke
CLIENT Hanke Kommunikation
TOOLS Macintosh, Adobe Photoshop,
Macromedia FreeHand

KAN TAI-KEUNG

CREATIVE DIRECTOR

28/F, 230 WANCHAI RD
WANCHAI, HONG KONG
TELEPHONE (852) 574 8399
FACSIMILE (852) 572 0199

DESIGN FIRM
Kan & Lau Design Consultants
ART DIRECTOR/DESIGNER
Kan Tai-keung
CLIENT
Tokong Link Design Centre Ltd.
PAPER/PRINTING
Gilbert White Cockle 216 gsm/Offset

DESIGN FIRM Stephen Peringer Illustration
DESIGNER/ILLUSTRATOR
Stephen Peringer
CLIENT Cool Hand Luke's Cafe

DESIGN FIRM Burgard Design
ALL DESIGN Todd Burgard
CLIENT Burgard Cycle
TOOLS Adobe Illustrator, Dimensions
PAPER/PRINTING Becket Expression Iceberg/
Two colors over one color

DESIGN FIRM Kan & Lau Design Consultants
ART DIRECTORS Kan Tai-keung, Freeman Lau Siu Hong
DESIGNER Freeman Lau Siu Hong
CLIENT Chex International Sales Ltd.
PAPER/PRINTING Conqueror Brilliant White Wove
220 gsm/Three-color offset

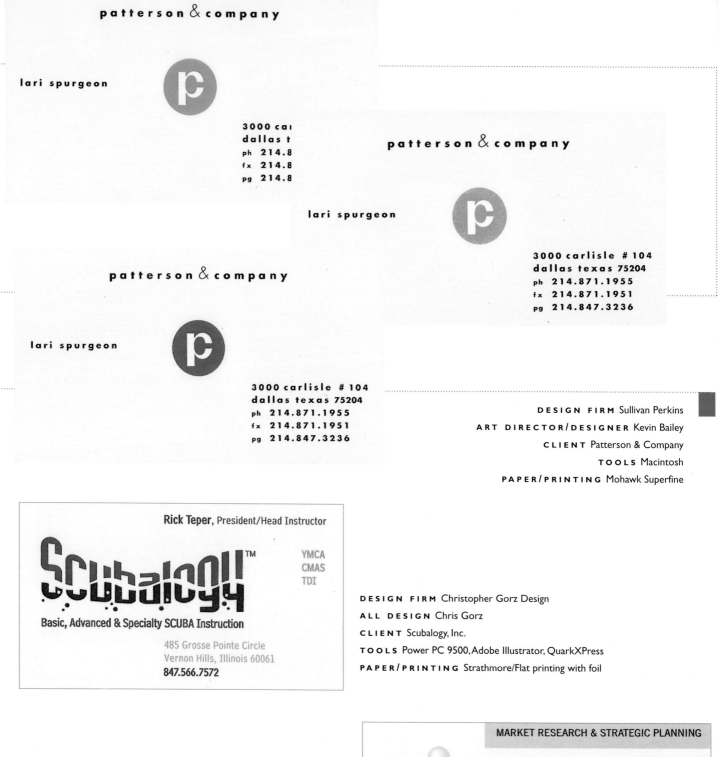

patterson & company

lari spurgeon

p

3000 car
dallas t
ph 214.8
fx 214.8
pg 214.8

patterson & company

lari spurgeon

p

3000 carlisle # 104
dallas texas 75204
ph 214.871.1955
fx 214.871.1951
pg 214.847.3236

patterson & company

lari spurgeon

p

3000 carlisle # 104
dallas texas 75204
ph 214.871.1955
fx 214.871.1951
pg 214.847.3236

DESIGN FIRM Sullivan Perkins
ART DIRECTOR/DESIGNER Kevin Bailey
CLIENT Patterson & Company
TOOLS Macintosh
PAPER/PRINTING Mohawk Superfine

Rick Teper, President/Head Instructor

Scubalogy™

YMCA
CMAS
TDI

Basic, Advanced & Specialty SCUBA Instruction

485 Grosse Pointe Circle
Vernon Hills, Illinois 60061
847.566.7572

DESIGN FIRM Christopher Gorz Design
ALL DESIGN Chris Gorz
CLIENT Scubalogy, Inc.
TOOLS Power PC 9500, Adobe Illustrator, QuarkXPress
PAPER/PRINTING Strathmore/Flat printing with foil

DESIGN FIRM Werk-Haus
ART DIRECTOR Ezrah Rahim
DESIGNERS Ezrah Rahim, Lai Yen Yee
CLIENT Margaret Chew
PAPER/PRINTING Cartenz/Two color, embossed

MARKET RESEARCH & STRATEGIC PLANNING

MARGARET CHEW
CONSULTANT

C1-04-4 Pantai Hillpark
Jalan Pantai Dalam
59200 Kuala Lumpur
Tel/Fax 03 282 9026

Tracie Meinhardt
Outreach Coordinator

23701 East Fork Road
Azusa, California 91702
(818) 910-1202
(818) 910-1380 *fax*
smrs@socmod.com

River Community
Touchstones

SOCIAL MODEL RECOVERY
SYSTEMS, INC.

DESIGN FIRM Adele Bass & Co. Design
ALL DESIGN Adele Bass
CLIENT Social Model Recovery Systems, Inc.
TOOLS Adobe Photoshop, Adobe Illustrator
PAPER/PRINTING Classic Columns/Two-color offset

Radon R. Lopez
Community Assistance Coordinator

1040 West
Santa Ana Boulevard
Suite 201
Santa Ana,
California 92703
714. 542. 1191
714. 542. 8136 *fax*

Developing healthy
and safe communities

COMMUNITIES IN PREVENTION, CENTRAL
A division of Social Model Recovery Systems, Inc.

DESIGN FIRM Adele Bass & Co. Design
ALL DESIGN Adele Bass
CLIENT Communities in Prevention, Central
TOOLS Adobe Photoshop, Adobe Illustrator
PAPER/PRINTING Classic Columns/Two-color offset

RIVER COMMUNITY

Bill Smith, *CSAC*
Recovery Specialist

River Community
23701 East Fork Road
Azusa, California 91702
(818) 910-1202
(818) 910-1380 *fax*

Adult Dual Diagnosis
Recovery Services

DESIGN FIRM Adele Bass & Co. Design
ALL DESIGN Adele Bass
CLIENT River Community
TOOLS Adobe Photoshop, Adobe Illustrator
PAPER/PRINTING Classic Columns/Two-color offset

SHIMOKOCHI/REEVES
IDENTITY & PACKAGE DESIGN CONSULTANTS
4465 WILSHIRE BLVD #305
LOS ANGELES CA 90010-3704
TEL: 213·937·3414
FAX: 213·937·3417

MAMORU SHIMOKOCHI
PRESIDENT/CREATIVE DIRECTOR

DESIGN FIRM Shimokochi/Reeves
ART DIRECTORS Mamoru Shimokochi, Anne Reeves
DESIGNER Mamoru Shimokochi
CLIENT Shimokochi/Reeves
TOOLS Adobe Illustrator
PAPER/PRINTING Classic Crest Writing
80 lb. Solar white cover white

Sam A. Angeloff

Sam A. Angeloff

Writing and Editing
for Visionary Businesses.

The writer's job is to tell a story
that is compelling, factual and
easily understood.

Clear and Direct
Original and Persistent
Accurate and Inventive
Adept and Cost-Effective

DESIGN FIRM Paper Power
ART DIRECTOR/DESIGNER Lyn Hourahine
CLIENT Paper Power
TOOLS Macintosh
PAPER/PRINTING Zeta matt Post Hammer
260 gsm/One color, diecut, offset litho

DESIGN FIRM Pen Ultimate
ALL DESIGN Sara Hanan
CLIENT Joe Hinnegan
TOOLS Initial and fonts after *Book of Kells,*
Macromedia Fontographer, CorelDraw

DESIGN FIRM Paper Power
ART DIRECTOR/DESIGNER Lyn Hourahine
DESIGNER Sherwin Schwartzrock
CLIENT Paper Power
TOOLS Macintosh
PAPER/PRINTING Zeta matt Post Hammer
260 gsm/One color, diecut, offset litho

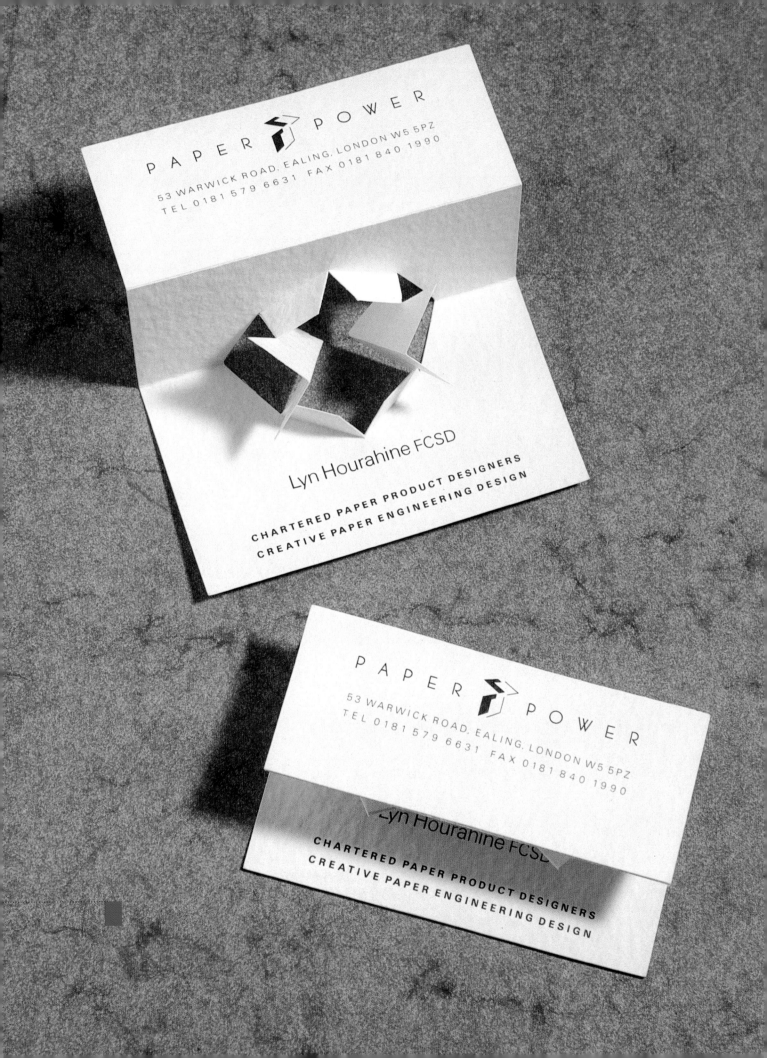

PAPER POWER

53 WARWICK ROAD, EALING, LONDON W5 5PZ
TEL 0181 579 6631 FAX 0181 840 1990

Lyn Hourahine FCSD

CHARTERED PAPER PRODUCT DESIGNERS
CREATIVE PAPER ENGINEERING DESIGN

PAPER POWER

53 WARWICK ROAD, EALING, LONDON W5 5PZ
TEL 0181 579 6631 FAX 0181 840 1990

Lyn Hourahine FCSD

CHARTERED PAPER PRODUCT DESIGNERS
CREATIVE PAPER ENGINEERING DESIGN